The Artist's Painting Library

CHILDREN'S PORTRAITS IN OIL

BY WENDON BLAKE / PAINTINGS BY GEORGE PASSANTINO

WATSON-GUPTILL PUBLICATIONS/NEW YORK

Copyright © 1980 by Billboard Ltd.

First published 1980 in the United States and Canada by Watson-Guptill Publications,
a division of Billboard Publications, Inc.,
1515 Broadway, New York, N.Y. 10036

Published in Great Britain by Pitman House, Ltd.,
39 Parker Street, London WC2B 5PB
ISBN 0-273-01366-1

Library of Congress Cataloging in Publication Data
Blake, Wendon.
 Children's portraits in oil.
 (His The artist's painting library)
 Originally published as pt. 2 of the author's The
portrait and figure painting book.
 1. Children—Portraits. 2. Portrait painting—
Technique. I. Passantino, George. II. Title.
III. Series: Blake, Wendon. Artist's painting
library.
ND1329.3.C45B56 1980 751.45'425 80-18897
ISBN 0-8230-0623-9 (pbk.)

Manufactured in U.S.A.

First Printing, 1980
Second Printing, 1981

CONTENTS

Painting Children's Portraits. The faces of children—sensitive, animated, and colorful—are the favorite subjects of many portrait painters around the world. Most children are wonderful portrait sitters. They look natural and relaxed because they're not consciously trying to look glamorous or important. They're open about their feelings, so their faces are full of tenderness and vitality. They're usually fascinated by the process of painting, full of questions, and easy to talk to. They're fun to be with *and* fun to paint.

Painting Children Step by Step. In the next few pages, you'll see a series of demonstrations painted in black and white. The distinguished portrait painter, George Passantino, starts by showing you the basic steps in painting a girl's head, from the preliminary brush drawing on the canvas through the buildup of the tones to the final touches and details. Then Passantino repeats the process, showing you the steps in painting a boy's head. Having seen two demonstrations of the steps in painting a complete head, you'll then find step-by-step demonstrations that show you how to paint each of the features: the eye, nose, mouth, and ear. Study these black-and-white demonstrations carefully before you go on to the demonstrations in color. It's important to learn how to visualize the head and its features in black-and-white because it's light and shadow that actually mold the forms. In fact, it's good practice to squeeze out a gob of black and a gob of white on your palette, mix them to produce a variety of grays, and paint a series of black-and-white portrait studies *before* you begin to work in color. When you've learned how to visualize the head as a pattern of lights, shadows, and halftones—halftones are those subtle tones that are darker than the lights but lighter than the darks—you're well on your way to painting an effective portrait.

Color Demonstrations. Following these black-and-white demonstrations, Passantino goes on to demonstrate how to paint ten different children's heads in color. These demonstrations cover a wide range of ages, from very young children to teenagers. You'll also find a great variety of hair and skin colors. First, you'll watch Passantino paint a girl with dark brown hair and pale, delicate skin, followed by a boy whose hair is a softer brown, but whose skin is darker. You'll learn how to paint a red-haired girl with freckled skin. Then you'll watch painting demonstrations that show how to render the delicate skin and hair tones of a blond girl and a blond boy. Dark-haired sitters can also have a variety of hair and skin tones and you'll see how these are handled in demonstration paintings of a young boy and a teenage girl. You'll see how to paint an oriental boy with black hair and pale skin. And finally, you'll watch two demonstration paintings of black children: a girl with soft, coffee-colored skin, and a boy whose skin is a ruddy brown. Above all, you'll discover that there are no formulas for painting different racial and ethnic types: each sitter has his or her own unique combination of hair and skin color—as unique as the sitter's personality.

Proportions, Lighting, Drawing. Children change rapidly, as you know, so it's particularly important to study the differences in children of different age groups. Following the color demonstrations, you'll find a series of sketches that analyze the head proportions of seven different children of various ages: two, five, seven, nine, eleven, twelve, and thirteen. You'll study four different ways of lighting children's portraits. And you'll watch a series of step-by-step demonstrations in which Passantino shows you how to draw portraits in pencil, charcoal, and chalk—and how to make an oil sketch.

Studying Children. Children have enormous energy and it's often difficult for *young* children to sit still for very long while you're working on a portrait. It's always important for a portrait painter to be quick and decisive—but this is doubly important when you're painting children. The secret, of course, is *practice*. Make a habit of drawing children at every opportunity. If there are children in your own household, ask if they'll sit for a quick sketch after dinner, while they're relaxing with a book or a magazine or in front of the television set. Invite the neighbors' kids in for a quick sketch. A brief drawing session each day will fill your sketchpad with information and rapidly develop your powers of observation. At the end of a year, you'll have a stack of sketchpads filled with drawings, but now all the information will be stored inside your head. It's also worthwhile to make lots of quick sketches in color. Buy a pad of light gray or tan drawing paper and a small box of colored chalks. Now these quick studies can begin to capture the colors of hair and skin. With hundreds of such sketches behind you—and stored in your "memory bank"—you'll be far more decisive and self-confident when you're standing at the easel.

Color Selection. For mixing flesh and hair tones, portrait and figure painters lean heavily on warm colors—colors in the red, yellow, orange, and brown range. As you'll see in a moment, these colors dominate the palette. However, even with a very full selection of these warm colors, the palette rarely includes more than a dozen hues.

Reds. Cadmium red light is a fiery red with a hint of orange. It has tremendous tinting strength, which means that just a little goes a long way when you mix cadmium red with another color. Alizarin crimson is a darker red with a slightly violet cast. Venetian red is a coppery, brownish hue with considerable tinting strength too. Venetian red is a member of a whole family of coppery tones which include Indian red, English red, light red, and terra rosa. Any one of these will do.

Yellows. Cadmium yellow light is a dazzling, sunny yellow with tremendous tinting strength, like all the cadmiums. Yellow ochre is a soft, tannish tone. Raw sienna is a dark, yellowish brown as it comes from the tube, but turns to a tannish yellow when you add white—with a slightly more golden tone than yellow ochre. Thus, yellow ochre and raw sienna perform similar functions. Choose either one.

Cadmium Orange. You can easily mix cadmium orange by blending cadmium red light and cadmium yellow light. So cadmium orange is really an optional color—though it's convenient to have.

Browns. Burnt umber is a rich, deep brown. Raw umber is a subdued, dusty brown that turns to a kind of golden gray when you add white.

Blues. Ultramarine blue is a dark, subdued hue with a faint hint of violet. Cobalt blue is bright and delicate.

Green. Knowing that they can easily mix a wide range of greens by mixing the various blues and yellows on their palettes, many professionals don't bother to carry green. However, it's convenient to have a tube of green handy. The bright, clear hue called viridian is the green that most painters choose.

Black and White. The standard black, used by almost every oil painter, is ivory black. Buy either zinc white or titanium white; there's very little difference between them except for their chemical content. Be sure to buy the biggest tube of white that's sold in the store; you'll use lots of it.

Linseed Oil. Although the color in the tubes already contains linseed oil, the manufacturer adds only enough oil to produce a thick paste that you squeeze out in little mounds around the edge of your palette. When you start to paint, you'll probably prefer more fluid color. So buy a bottle of linseed oil and pour some into that little metal cup (or "dipper") clipped to the edge of your palette. You can then dip your brush into the oil, pick up some paint on the tip of the brush, and blend oil and paint together on your palette.

Turpentine. Buy a big bottle of turpentine for two purposes. You'll want to fill that second metal cup, clipped to the edge of your palette, so that you can add a few drops of turpentine to the mixture of paint and linseed oil. This will make the paint even more fluid. The more turpentine you add, the more liquid the paint will become. Some oil painters like to premix linseed oil and turpentine, 50-50, in a bottle to make a thinner *painting medium*, as it's called. They keep the medium in one palette cup and pure turpentine in the other. For cleaning your brushes as you paint, pour some more turpentine into a jar about the size of your hand and keep this jar near the palette. Then, when you want to rinse out the color on your brush and pick up a fresh color, you simply swirl the brush around in the turpentine and wipe the bristles on a newspaper.

Painting Mediums. The simplest painting medium is the traditional 50-50 blend of linseed oil and turpentine. Many painters are satisfied to thin their paint with that medium for the rest of their lives. On the other hand, art supply stores do sell other mediums that you might like to try. Three of the most popular are damar, copal, and mastic painting mediums. These are usually a blend of natural resin—called damar, copal, or mastic, as you might expect—plus some linseed oil and some turpentine. The resin is really a kind of varnish that adds luminosity to the paint and makes it dry more quickly. Once you've tried the traditional linseed oil–turpentine combination, you might like to experiment with one of these resinous mediums. You might also like to try a gel medium. This is a clear paste that comes in a tube.

Palette Layout. Before you start to paint, squeeze out a little dab of each color on your palette, plus a *big* dab of white. Establish a fixed location for each color, so you can find it easily. One good way is to place your *cool* colors (black, blue, green) along one edge and the *warm* colors (yellow, orange, red, brown) along another edge. Put the white in a corner where it won't be soiled by the other colors.

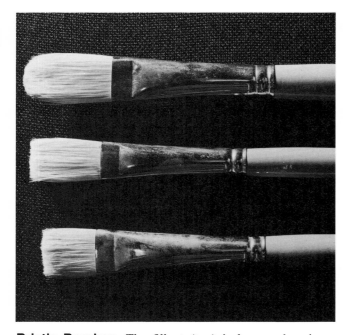

Bristle Brushes. The filbert (top) is long and springy, comes to a rounded tip, and makes a soft stroke. The flat (center) has a squarish tip and makes a more rectangular stroke. The bright (bottom) also makes a rectangular stroke, but the bristles are short and stiff, leaving a strongly textured stroke.

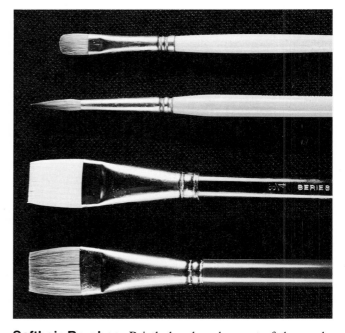

Softhair Brushes. Bristle brushes do most of the work, but softhair brushes are helpful for smoother, more precise brushwork. The top two are sables: a small, flat brush that makes rectangular strokes; a round, pointed brush that makes fluid lines. At the bottom is an oxhair brush, while just above it is a soft, white nylon brush; both make broad, smooth, squarish strokes.

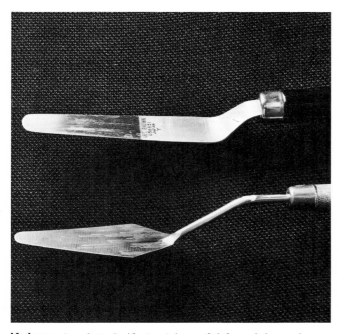

Knives. A palette knife (top) is useful for mixing color on the palette, for scraping color off the palette at the end of the painting session, and for scraping color off the canvas when you're dissatisfied with what you've done and want to make a fresh start. A painting knife (bottom) has a very thin, flexible blade that's specially designed for spreading color on canvas.

Easel. A wooden studio easel is convenient. Your canvas board, stretched canvas, or gesso panel is held upright by wooden "grippers" that slide up and down to fit the size of the painting. They also adjust to match your own height. Buy the heaviest and sturdiest you can afford, so it won't wobble when you attack the painting with vigorous strokes.

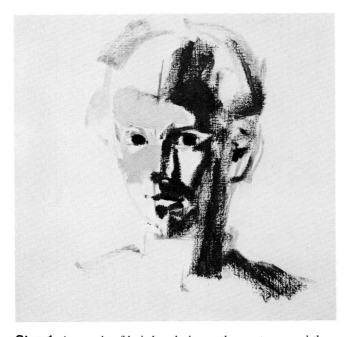

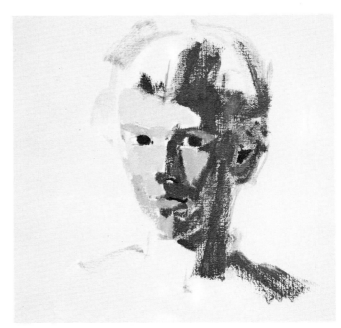

Step 1. A round softhair brush draws the contours and then a big bristle brush blocks in the shadows. The brush also locates dark patches within the eyes and ear. Another bristle brush begins to cover the lighted patches of the face. The brush moves quickly to establish the broad pattern of lights and shadows—it's not important to cover the canvas evenly.

Step 2. A bristle brush completes the tonal pattern of the face by adding the halftones that appear within the eyesockets; between the eyes; and on the cheeks, lower lip, and chin. The lights, halftones, and the shadows are as flat and simple as a poster.

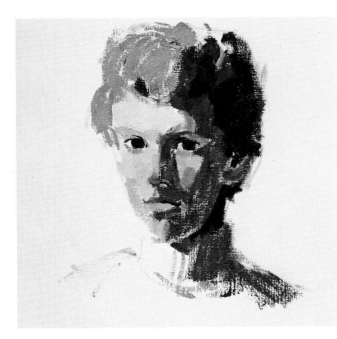

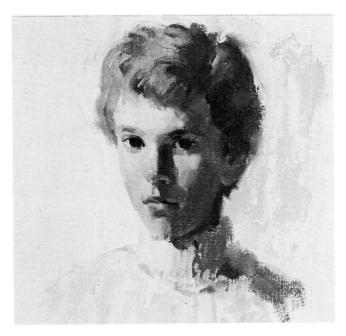

Step 3. Now a big bristle brush begins to adjust the tones. First, the brush completes the shadow side of the hair, darkens the back of the neck, and covers the lighted planes of the hair. Then the brush adds more halftones to the eyes, nose, cheeks, and chin. The tip of a round brush begins to refine the contours of the eyelids and the mouth. The brushwork is still broad and flat.

Step 4. A flat, softhair brush moves over the areas where light, shadow, and halftone meet—softly brushing them together to make the face look three-dimensional. A small bristle brush adjusts the tones, darkening the shadow on the side of the nose, filling the eyesockets with more tone, and strengthening the contours of the lips. A round brush sharpens the eyelids, the eyebrows, and the line between the lips.

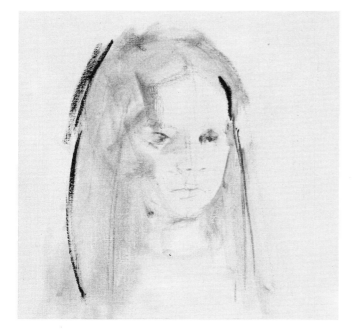

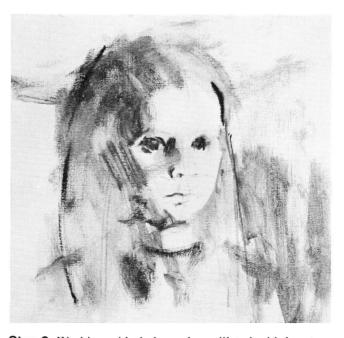

Step 1. A round softhair brush draws the contours of the head and then locates the features with tube color thinned with turpentine to the consistency of watercolor. A flat bristle brush picks up this color and begins to adjust the shadows on the hair, forehead, cheek, jaw, and neck, also adding touches of shadow within the eyesockets.

Step 2. Working with darker color—diluted with less turpentine—a small bristle brush darkens the shadows on the hair, forehead, cheek, jaw, chin, and neck. The shadow is indicated alongside the nose. More darks are added to the eyes. The brush begins to darken the hair and the background. A round brush sharpens the lines of the nose and the mouth.

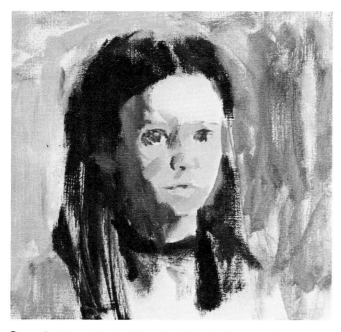

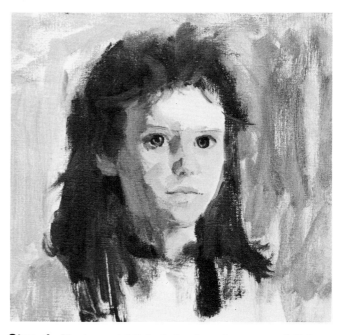

Step 3. The color is diluted with painting medium to the consistency of thin cream. Now a large bristle brush paints the darks as big, flat shapes. Another bristle brush paints the big lighted patches on the front of the face. A small bristle brush begins to add the halftones—those subtle tones which are lighter than the shadows, but darker than the lights.

Step 4. Having established the broad pattern of lights, shadows, and halftones, the large bristle brush begins to adjust these tones. Paler mixtures are brushed over the hair and into the shadow side of the face and neck. Stronger darks are added to the shadow side of the nose. Small brushes strengthen the tones and details of the eyes, nose, and lips.

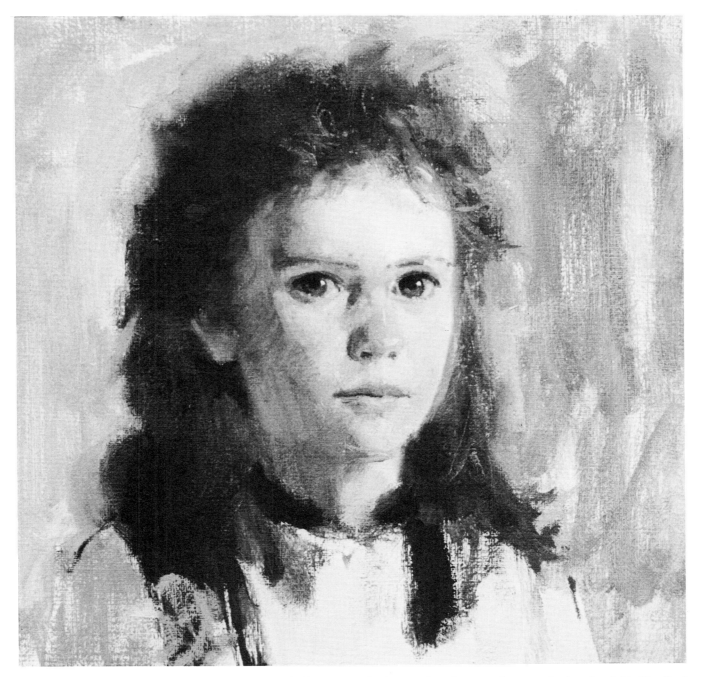

Step 5. The blending of the lights, shadows, and halftones is saved for the final stages. Now a flat brush—which can be either a bristle or a softhair—softens the areas where the lights, halftones, and shadows meet. However, the brush doesn't "iron out" the original strokes, but allows the lively, casual brushwork to remain. You can see this most clearly on the shadow side of the cheek and jaw. A big bristle brush moves over the hair, blending the strokes, softening the tones, and roughening the edges of the hair where it melts away into the background. At the left, the big bristle brush blends and smoothes the background tone to contrast with the rough brushwork of the hair; however, the original background strokes remain untouched at the right. The final touches and details are saved for the very end. The tip of a round softhair brush completes the eyes and the eyebrows, then moves down to sharpen the contours of the nose and the mouth. The small brush doesn't overdo these details. One nostril is more distinct than the other. The dark line between the lips fade away at the right. The tip of the small brush adds just a few highlights to the eyes, nose, and lower lip. Observe how the outer contours of the face remain soft and slightly blurred. This is produced by free, casual brushwork that's particularly suitable for the softness of the young girl's face.

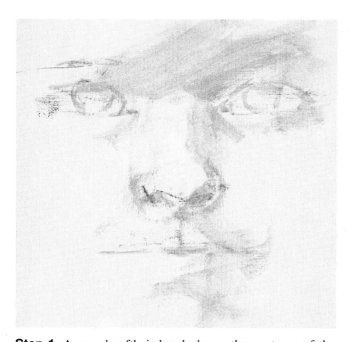

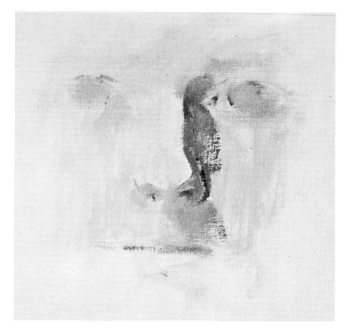

Step 1. A round softhair brush draws the contours of the nose at the same time as all the other features. The brush indicates the shadow above the bridge of the nose; the shadow on one side of the nose; the nostrils and the shadowy underside of the nose; the valley beneath the nose; and the diagonal shadow that's cast by the nose downward to the upper lip.

Step 2. A bristle brush covers the original brush lines with solid tones. Now there's a strong shadow on one side of the nose, leading from the eyesocket down the bridge of the nose to the nostril. The shadowy underside of the nose is indicated by a soft tone that's carried diagonally downward over one side of the upper lip.

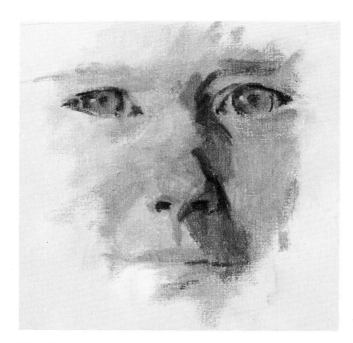

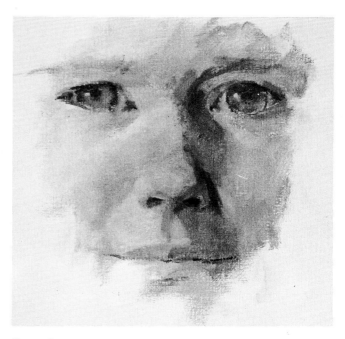

Step 3. A big bristle brush adds the lights and halftones on the nose and on the surrounding cheeks, brow, and upper lip. A smaller bristle brush strengthens the darks on the shadow side of the nose, indicates the nostrils, and solidifies the shadow that's cast by the nose over the upper lip. At the same time, work continues on the other features.

Step 4. It's time to begin adjusting the tones. The brush solidifies the big shadow on the side of the nose into one continous tone, then softens and lightens the harsh shadow strokes that appear in Step 3. The lighted planes of the nose, cheeks, and upper lip also become softer and paler. The tip of a round brush begins to define the nostrils more precisely.

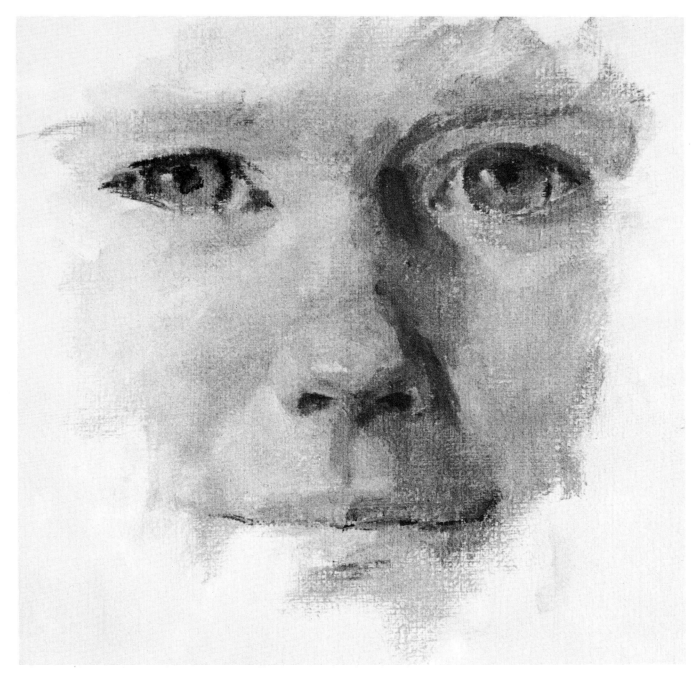

Step 5. In the final stage, a flat softhair brush blends the shadow side of the nose delicately into the lighted cheek at the right. This same brush softens the meeting place of the lighted front of the nose with the shadow side. The blending action of the softhair brush makes the underside of the nose look rounder and then blurs the shadow cast on the upper lip. The shadow side of the nose is strengthened in only one place: the flat softhair brush adds a single dark where the bridge of the nose meets the corner of the eyesocket. Then the tip of a round softhair brush completes the job by sharpening the dark shapes of the nostrils and adding a highlight at the tip of the nose. Throughout the child's face, the softhair brush carefully blurs all harsh lines except for the edges of the eyelids, the darks of the nostrils, and the slender line where the lips come together.

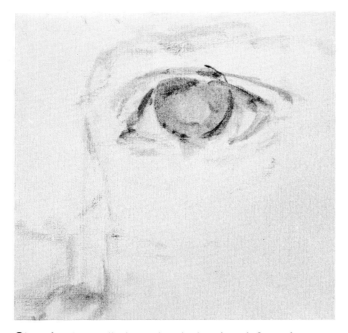

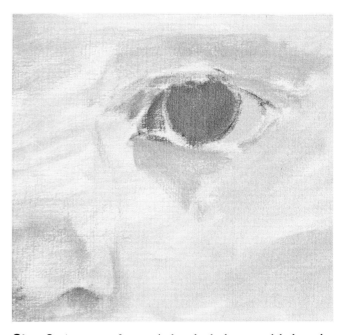

Step 1. The preliminary brush drawing defines the outer shape of the eye, the line of the upper lid, and the circle of the iris—which is overlapped by the upper lid. (Remember that you almost never see the full circle of the iris.) A hint of tone suggests the darker color of the iris—plus the shadow that's cast by the upper lid on the iris and on the white of the eye.

Step 2. A very soft tone is brushed above and below the eye to suggest the delicate shadows within the eyesockets. The iris is covered with a flat tone. Some of this tone is added to the shadowy inner corner of the eye. A paler tone is brushed over the white of the eye.

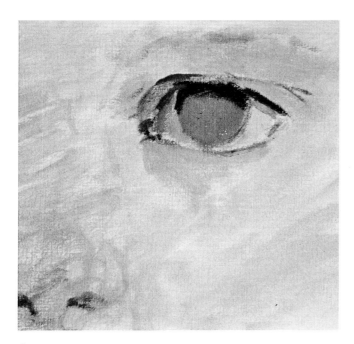

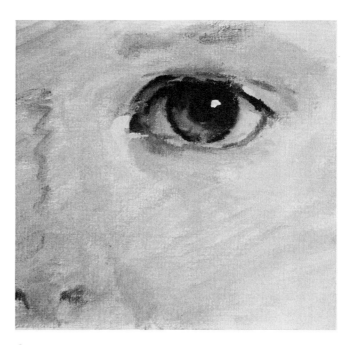

Step 3. The tip of a round brush adds the slender shadow lines that appear along the edges of the lids. The brush also adds the curving shadow that the upper lid casts on the iris and on the white of the eye, which you can see most clearly at the right. The shadowy inner corner of the eye is blended with a softhair brush.

Step 4. The shadowy upper lid is darkened slightly. Then the iris is darkened too and the pupil is added at the center. The tip of a round brush traces the dark edge of the iris; darkens the shadowy edges of the lids; strengthens the shadow at the inner corner of the eye; and adds a single bright highlight to the pupil—not at the center, but off to one side.

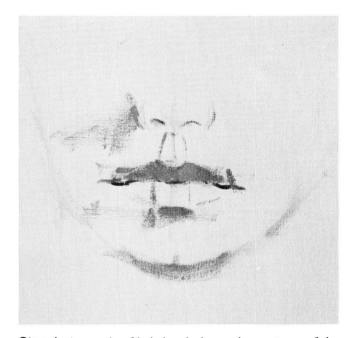

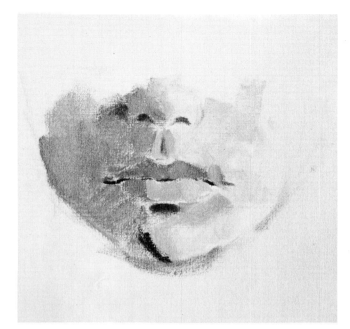

Step 1. A round softhair brush draws the contours of the mouth and the surrounding features. A bristle brush fills the upper lid with a solid tone and repeats this tone beneath the lower lip. The upper lip is usually in shadow, while the lower lip is usually brighter. Touches of shadow are suggested at the corner of the nose and beneath the chin.

Step 2. A big bristle brush covers the shadow side of the face with a broad, continuous tone. A smaller bristle brush paints the shadowy side plane of the lower lip and then adds the lighted areas. A big bristle brush covers the lighted planes of the face above and below the lips. The shadow beneath the lower lip is strengthened and a touch of shadow is added to the chin.

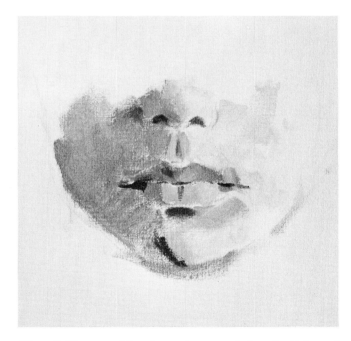

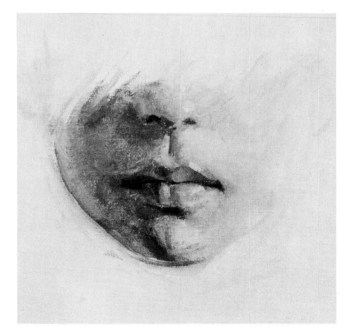

Step 3. The round brush continues to define the light and shadow planes of the lips, which are more complex than they might seem at first glance. The corners of the lips are darkened. A shadowy cleft divides the lower lip. And a touch of shadow is added to accentuate the central curve of the upper lip.

Step 4. A softhair brush darkens the shadow sides of the lips, blends the tones, and blurs them softly into the surrounding skin so there's no harsh dividing line. The lighted areas of the lips are brightened with paler color. The dark corners of the mouth are blurred and then the tip of a round brush strengthens the dark dividing line where the lips meet.

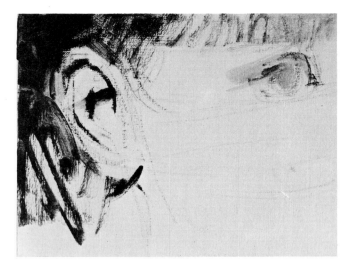

Step 1. The preliminary brush drawing defines the outer and inner contours of the ear. After more turpentine is added to produce a liquid wash something like watercolor, the brush adds a few broad, dark strokes to suggest the hair behind the ear and the pool of shadow within the ear. A pale guideline indicates that the top of the ear lines up roughly with the top of the eye.

Step 2. The brush surrounds the ear with dark hair to accentuate the pale tone of the skin. Then the brush traces the shadowy edges of the rim within the ear, and the shadowy underside of the lobe. Finally, the brush adds a pool of shadow within the center of the ear.

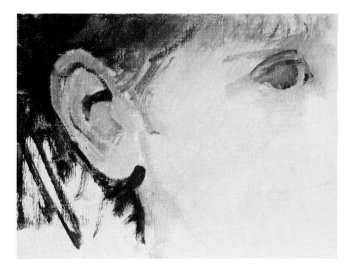

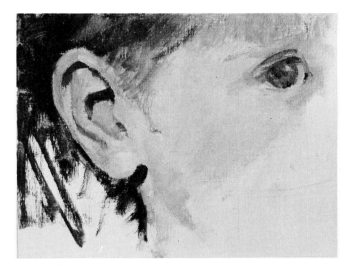

Step 3. The lighted areas of the ear are painted with color that's diluted with painting medium to the consistency of thin cream. The lines of shadow begin to disappear under these pale tones—but the darks will be re-established soon. The lighted contours of the ear are now clearly separated from the dark hair and the background.

Step 4. The tip of a round brush reinforces the pool of shadow beneath the upper rim of the ear and strengthens the other shadow lines within the ear. Notice the subtle half-tones that make the lobe look rounder and that deepen the depression at the center of the ear.

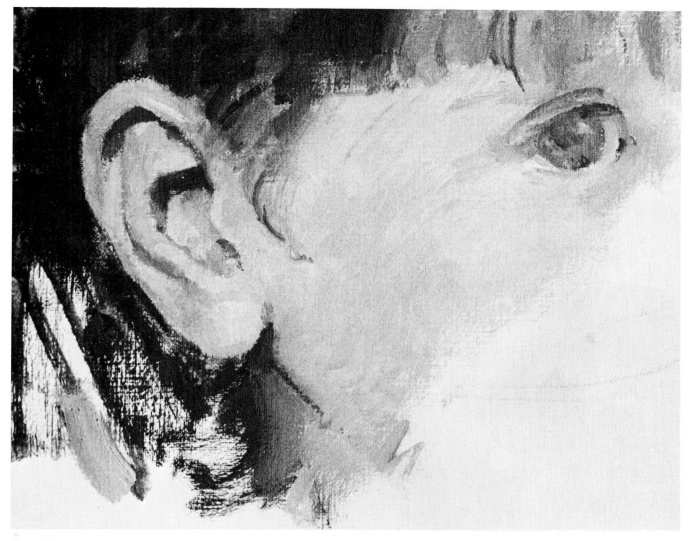

Step 5. In the final stage, the round softhair brush refines some of the forms and intensifies the lights. Compare Step 4 and Step 5 to see how the shadow at the corner of the ear-lobe is reshaped. Within the ear, the curving pools of shadow are softened and blurred as the dark shapes move downward toward the lighted skin. The tip of the brush adds touches of light along the rim, within the bowl of the ear, and along the thick, curving ridge at the center of the ear. It's important to study the contours of the ear carefully. It's not just an ellipse with a dark hole in the middle—as too many beginners paint it—but a complex pattern of shapes. The outer contour is composed of a series of short lines, many of which are surprisingly straight, until you get to the curving top of the ear. Discipline yourself by drawing the ear again and again until you memorize the form.

Buying Brushes. There are three rules for buying brushes. Buy the best you can afford—even if you can afford only a few. Buy big brushes, not little ones; big brushes encourage you to work in bold strokes. And buy brushes in pairs, roughly the same size. For example, if you're painting the light and shadow planes of a face, you can use one big brush for the shadows, but you'll want another big brush, unsullied by dark colors, to paint the skin in bright light.

Recommended Brushes. Begin with a couple of really big bristle brushes, around 1″ (25 mm) wide for painting your largest color area. Try two different shapes: possibly a flat and a filbert, one smaller than the other. Then you'll need two or three bristle brushes about half this size; again, try a flat, a filbert, and perhaps a bright. For painting smoother passages, details, and lines, three softhair brushes are useful: one that's about 1/2″ (25m mm) wide; one that's about half this wide; and a pointed, round brush that's about 1/8″ or 3/16″ (3-5 mm) thick at the widest point.

Knives. For mixing colors on the palette and for scraping a wet canvas when you want to make a correction, a palette knife is essential. Many oil painters prefer to mix colors with the knife. If you like to *paint* with a knife, buy a painting knife with a short, flexible, diamond-shaped blade.

Painting Surfaces. When you're starting to paint in oil, you can buy inexpensive canvas boards at any art supply store. These are canvas coated with white paint and glued to sturdy cardboard in standard sizes that will fit into your paintbox. Another pleasant, inexpensive painting surface is canvas-textured paper that you can buy in pads, just like drawing paper. (Many of the demonstrations in this book are painted on canvas-textured paper.) Later, you can buy stretched canvas—sheets of canvas, precoated with white paint and nailed to a rectangular frame made of wooden stretcher bars. You can save money if you buy stretcher bars and canvas, then assemble them yourself. If you like to paint on a smooth surface, buy sheets of hardboard and coat them with acrylic gesso, a thick, white paint that you can thin with water.

Easel. An easel is helpful, but not essential. It's just a wooden framework with two ''grippers'' that hold the canvas upright while you paint. The ''grippers'' slide up and down to fit larger or smaller paintings—and to match your height. If you'd rather not invest in an easel, you can improvise. One way is to buy a sheet of fiberboard about 1″ (25 mm) thick and hammer a few nails part way into the board, so the heads of the nails overlap the edges of the painting and hold it securely.

Prop the board upright on a tabletop or a chair. Or you can just tack canvas-textured paper to the fiberboard.

Paintbox. To store your painting equipment and to carry your gear from place-to-place, a wooden paintbox is convenient. The box has compartments for brushes, knives, tubes, small bottles of oil and turpentine, and other accessories. It usually holds a palette—plus canvas boards inside the lid.

Palette. A wooden paintbox often comes with a wooden palette. Rub the palette with several coats of linseed oil to make the surface smooth, shiny, and nonabsorbent. When the oil is dry, the palette won't soak up your tube color and will be easy to clean at the end of the painting day. Even more convenient is a paper palette. This looks like a sketchpad, but the pages are nonabsorbent paper. You squeeze out your colors on the top sheet. When you're finished, you just tear off and discard the top sheet. Paper palettes come in standard sizes that fit into your paintbox.

Odds and Ends. To hold turpentine, linseed oil, or painting medium, buy two metal palette cups (or ''dippers''). Make a habit of collecting absorbent, lint-free rags to wipe mistakes off your painting. Paper towels or old newspapers (a lot cheaper than paper towels) are essential for wiping your brush after rinsing in turpentine.

Furniture. Be sure to have a comfortable chair or couch for your model. Not many people have the stamina to *stand* for hours while they're being painted! If you're working at an easel, you're probably standing while the model sits or sprawls—which means that the model is below your eye level. That's why professional portrait and figure painters generally have a model stand. This is just a sturdy wooden platform or box about as high as your knee and big enough to accommodate a large chair or even a small couch. If you're handy with tools, you can build it yourself. (Of course, you can always work sitting down!) Another useful piece of equipment is a folding screen on which you can hang pieces of colored cloth—which can be nothing more than old blankets—to create different background tones.

Lighting. If your studio or workroom has big windows or a skylight, that may be all the light you need. Most professionals really prefer natural light. If you need to boost the natural light in the room, don't buy photographic floodlights; they're too hot and produce too much glare. Ordinary floor lamps, tabletop lamps, or those hinged lamps used by architects will give you softer more ''natural'' light. If you have fluorescent lights, make sure that the tubes are ''warm white.''

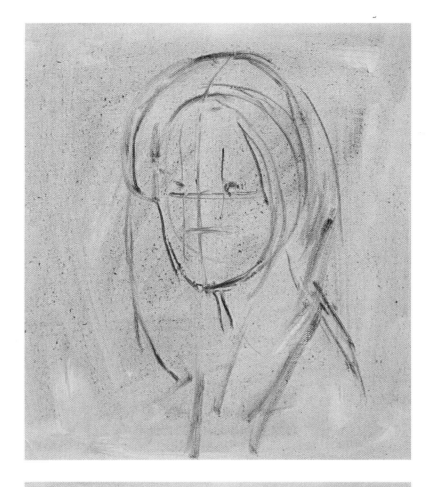

Step 1. Ultramarine blue and raw umber are blended on the palette and diluted with turpentine to the consistency of watercolor. A clean rag picks up this mixture and wipes it over the canvas. Then a round, softhair brush picks up this same mixture—but with less turpentine—to make the preliminary brush drawing. The drawing begins with the curved lines of the head and the surrounding hair, the straighter lines of the hair falling across the shoulders, and the lines of the neck and shoulder. The brush draws a vertical center line through the face and then places another vertical line on either side of that center line. Across these vertical guidelines, the brush carries horizontal lines to locate the eyes and the underside of the nose. In Step 2 you'll see how these guidelines work.

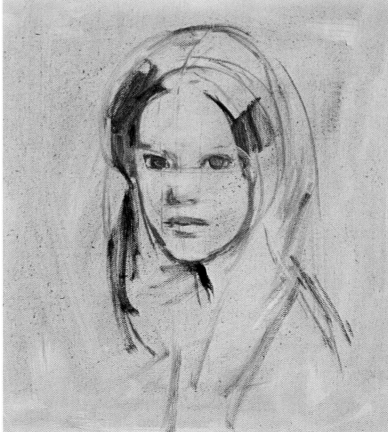

Step 2. Working with this same mixture of ultramarine blue, raw umber, and turpentine, the tip of the round brush draws the outer contours of the face more precisely, paying particular attention to the shapes of the jaw and chin. Then the artist refers to the vertical and horizontal guidelines to place the features. Now you can see that the purpose of these guidelines is to establish the relationships of the features. In this particular view of the face—which is turned slightly to the left—the center line shows that the corner of one eye socket lines up (approximately) with the tip of the nose and the center of the lips. The vertical guideline at the left shows that the iris is directly above the corner of the mouth. The vertical guideline at the right shows that the corner of the eye falls above the corner of the mouth. Whenever you begin to draw a head, look for these vertical alignments—which change radically as the head turns. At the end of Step 2 a bristle brush begins to add the dark tone of the hair.

Step 3. A bristle brush completes the preliminary sketch by covering the hair with rough strokes of ultramarine blue, raw umber, and turpentine. The strokes actually follow the direction in which the hair wraps around the head and falls over the shoulders. Notice that the sketch also records the very delicate shadows within one eye socket, on one side of the nose, on the upper lip, and beneath the lower lip. A few scribbly background strokes suggest the irregular background texture that will begin to appear in the next step.

Step 4. A large bristle brush picks up a mixture of raw umber, cadmium orange, and a touch of ultramarine blue to begin the dark color of the hair. A round softhair brush picks up this same mixture to darken the eyes and strengthen the lines of the eyes, eye sockets, nose, mouth, and jaw. It's always important to begin work on the background as early as possible; so now a painting knife blends ultramarine blue, raw umber, and white on the palette and then surrounds the head with broad, flat strokes.

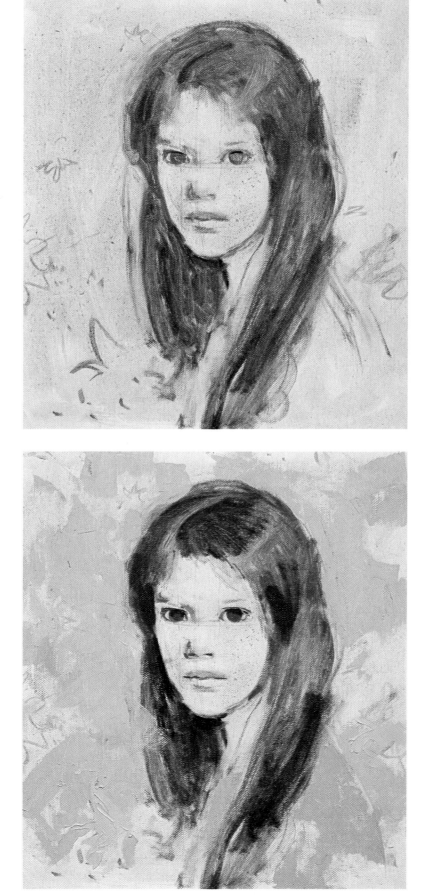

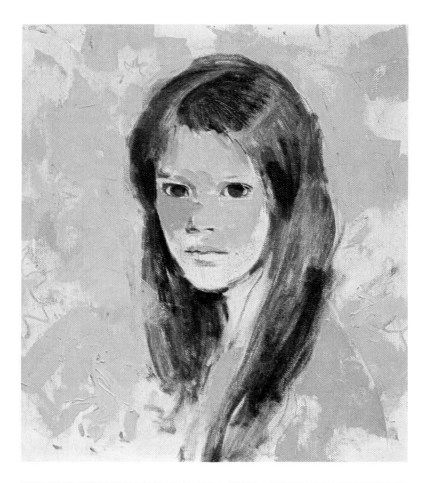

Step 5. A bristle brush begins to lay in the flesh tones with various mixtures of raw umber, Venetian red, raw sienna, and white, diluted with painting medium. The forehead receives the strongest light, and therefore the flesh mixture contains the most white. Starting with the tone between the eyes, the lower half of the face is distinctly darker. The shadow side of the face is only slightly darker than the lighted cheek. But this gradual change from light to dark is important because it gives the face a feeling of roundness. If this head had a strong, distinct pattern of light and shadow, the artist would begin with the darks and *then* block in the lights. But here the lights and darks are so similar to one another that the artist works on them all at the same time.

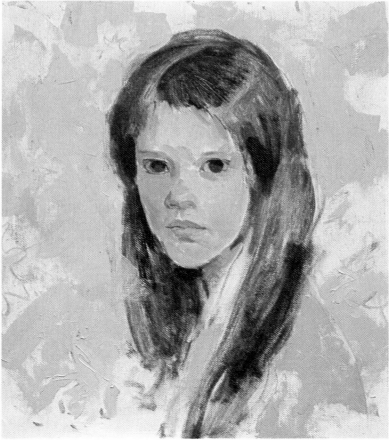

Step 6. The bristle brush covers the entire lower face and neck with color, continuing to work with various mixtures of raw umber, Venetian red, raw sienna, and white. The lighted side of the face contains more white. There's more Venetian red in the warm shadows within the eye sockets, along the shadow side of the nose and cheek, within the lips, and on the neck. The shadows are all very soft. Notice how the tone of the eye socket on the lighted side of the face is only *slightly* darker than the lighted cheek below. This same very soft shadow tone appears beneath the nose and within the vertical valley that leads from the nose to the upper lip. At first glance the entire face seems to be in light, but there's definitely a shadow side—and you can also see some halftones where the lights and shadows meet, such as the bridge of the nose. A little more Venetian red is added to the flesh mixture for the color of the lips.

Step 7. Having covered the face with lights, halftones, and shadows, the brush begins to blend them together. Now the face has a softer, rounder look. The lighted cheek is warmed by adding a little cadmium red to the mixture. Still more cadmium red is added to enrich the tone of the lips—though the artist carefully avoids a harsh "lipstick red." Blending more raw umber into the flesh mixture, the brush adds shadows where the hair overhangs the forehead and blends some of this tone into the hair where it parts at the left. A small bristle brush sharpens the contour of the shadow side of the face, where it meets the hair. Adding more raw umber to the flesh mixture, a round brush sharpens all the features. Then this brush paints the darks of the eyes more precisely with burnt umber and ultramarine blue.

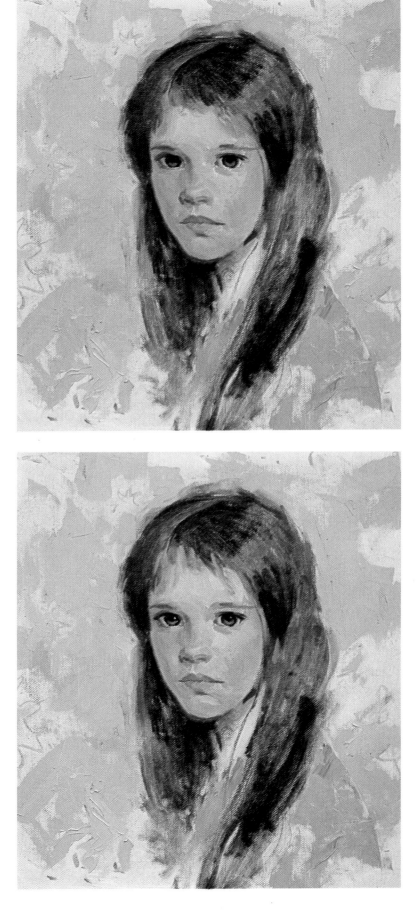

Step 8. Blending more white into the flesh mixture, a small bristle brush builds up the lighted areas on the forehead and cheek, the tip of the nose, the upper lip, and the chin. Now there's a stronger contrast between the lights and the shadows. You can see this most clearly when you look at the shadowy lower lid of the eye on your right, which now contrasts more strongly with the lighted cheek beneath. In the same way there's a stronger contrast between the shadowy underside of the nose and the lighted upper lip. A bristle brush blends more shadowy skin tone into the surrounding hair. A round brush continues to sharpen the lines of the eyes with burnt umber and ultramarine blue, adding highlights to the pupils with pure white tinted with flesh tone. The whites of the eyes are actually a very pale skin tone.

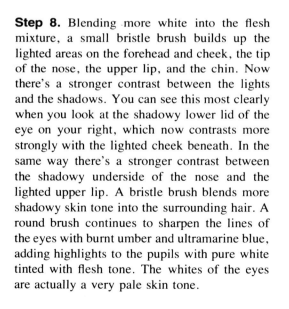

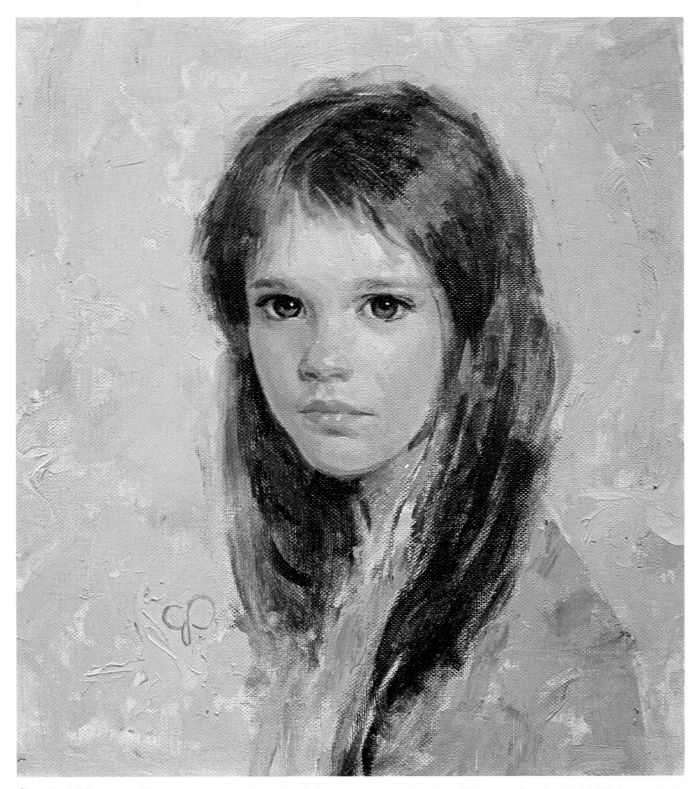

Step 9. Adding more Venetian red and a hint of cadmium red to the flesh mixture, a flat softhair brush enriches the flesh tone, blending these soft strokes into the lights that were added in Step 8. A softhair brush blends other contours, such as the shadow side of the nose, the pool of shadow beneath the lower lip, and the shadowy lower lid on the lighted side of the face. A round brush defines the eyelids and then darkens the eyebrows with burnt umber and ultramarine blue. This same brush adds highlights to the tip of the nose and the lower lip with quick touches of the palest flesh tone. A big bristle brush sweeps long strokes of Venetian red, ultramarine blue, burnt umber, and white over the hair. A round brush picks out a few individual strands of hair. The background and the dress are completed with broad brush and knife strokes of ultramarine blue, raw umber, and white.

Step 1. A rag wipes the canvas with a pale mixture of raw umber, ultramarine blue, and lots of turpentine. A big bristle brush picks up a slightly darker version of this mixture—containing less turpentine—and covers the face and chest with this tone to indicate the darkest areas of the picture. Then a round softhair brush begins the preliminary brush drawing with this same combination of colors diluted with turpentine. The brush draws the outer shapes of the face and hair; draws two vertical center lines, which will help to locate not only the features, but the shadow on one side of the nose; and draws horizontal guidelines for the features. A single touch of the brush locates the center of each eye. These horizontal lines also help to locate the ears.

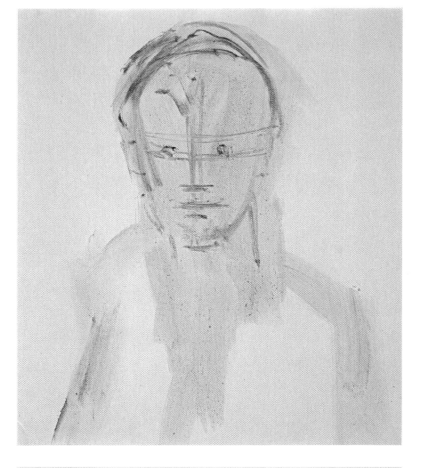

Step 2. Still working with ultramarine blue, raw umber, and plenty of turpentine, the round softhair brush continues to develop the preliminary drawing. A cloth wipes away some excess lines, and then the brush defines the shapes of the hair, ears, cheeks, jaw, and chin more precisely. The neck is visualized as a simple cylinder. Following the guidelines drawn in Step 1, the brush fills the eye sockets with tone; indicates the darks of the eyes; and darkens the underside of the nose, the upper lip, and the shadow beneath the lower lip. A rag wipes away the lights on the face.

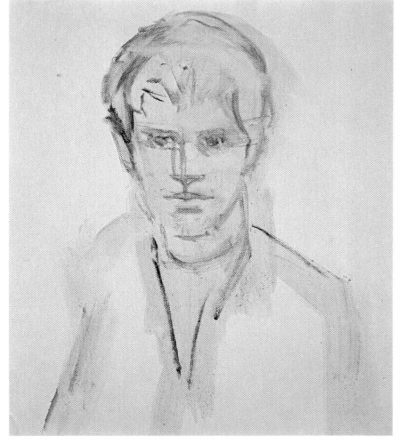

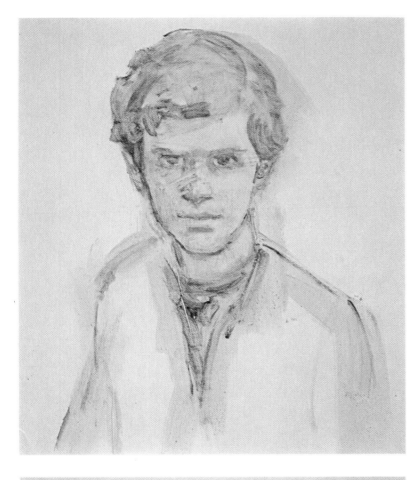

Step 3. The round brush draws the contours of the face with precise lines that capture the squarish character of the jaw and chin. The tip of the brush draws the eyes more precisely, refines the contours of the nose and lips, and fills the shadow side of the nose with a tone that follows the two vertical guidelines that first appeared in Step 1. A flat brush fills the shadow side of the face with tone and moves swiftly over the hair to solidify its shape. A scrubby tone suggests the dark shape of the scarf. Unlike the girl's head in Demonstration 1, this head has a strong pattern of light and shadow, which is important to capture in the preliminary brush drawing.

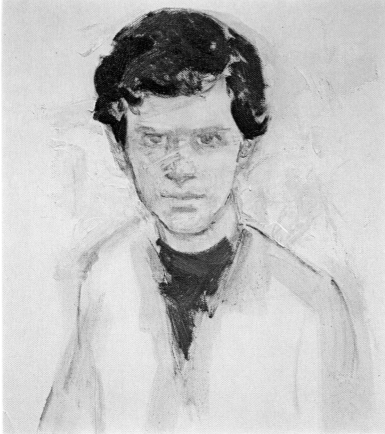

Step 4. A big bristle brush covers the lighted area of the hair with broad, curving strokes of burnt umber, raw sienna, ultramarine blue, and a little white. The shadow areas of the hair are painted with this same mixture with less white. The cool, dark tone of the scarf is quickly scrubbed in with cobalt blue, alizarin crimson, and white. Now the canvas contains the two strongest darks that will appear in the portrait. Work begins on the background with cobalt blue, alizarin crimson, and lots of white. From this point on, all mixtures are diluted with painting medium.

Step 5. A round softhair brush begins to strengthen the shadows by adding crisp touches of darkness, beginning with the features. Working with a mixture of raw umber, Venetian red, and a little white, diluted with painting medium, the tip of the brush darkens the contours of the eyes and adds a strong shadow to one eye socket, darkens the underside of the nose and the line of the mouth, and sharpens the forms of the ears. The brush also adds strong touches of shadow on one cheek and on the side of the neck.

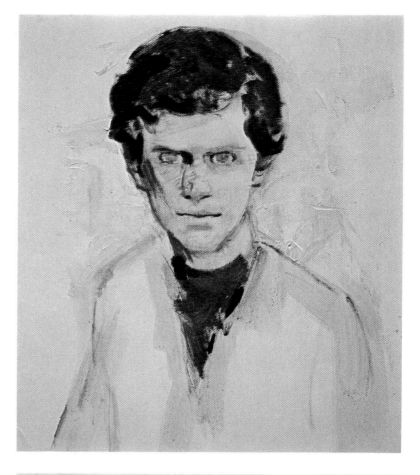

Step 6. A small bristle brush completes the pattern of shadows with raw umber, raw sienna, Venetian red, and white, diluted with painting medium. The brush works downward, beginning with the shadow that's cast by the hair over the forehead and then moving on to the brow, cheek, jaw, chin, and neck on the dark side of the face. The brush also fills the eye sockets with tone. Adding more Venetian red and raw umber the brush darkens the iris of each eye; adds rich, warm shadows to the cheek and the side of the nose; and warms the color of the ear in shadow. A round brush paints the shadowy upper lip and the pool of shadow beneath the lower lip. Now all the shadow areas are clearly defined.

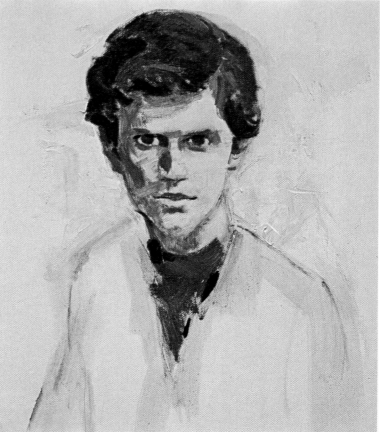

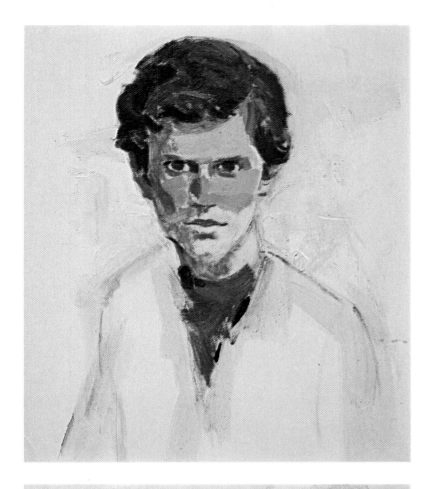

Step 7. Moving on to the lighted areas of the face, a bristle brush covers the forehead with raw umber, Venetian red, raw sienna, and plenty of white. This same mixture—with less white—is carried over the lighted cheek. Then more Venetian red is added to paint the nose, the underside of the lighted cheek, and the patch of light that appears on the opposite cheek. As usual the upper half of the face is brightest, while the lower half of the face grows gradually darker.

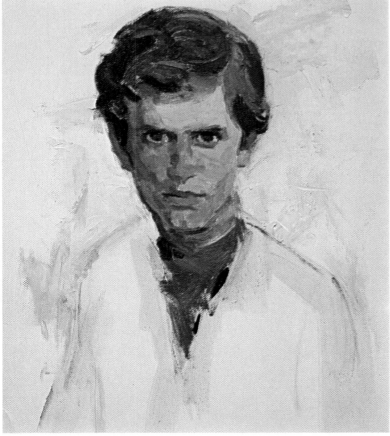

Step 8. A bristle brush completes the lower half of the face, still working with various mixtures of raw umber, Venetian red, raw sienna, and white. The warm tones—such as those on the shadow side of the head—contain more Venetian red and raw sienna. The more muted tones—such as those on the chin, beneath the nose, and on the jaw beneath the lighted cheek—contain more raw umber. More Venetian red is added to the flesh mixture to produce the warm tone of the lips. Thie whites of the eyes are painted with the palest flesh tone—never with pure white straight from the tube. Notice the halftones where the lights and shadows meet at places like the brow and the chin. The tone of the hair is enriched with strokes of raw umber, raw sienna, and white.

Step 9. A small, flat brush—either bristle or softhair—begins to blend the areas where lights, halftones, and shadows meet. Compare the cheeks in Step 8 with those in Step 9 to see how the original harsh brushstrokes melt away into soft, continuous tones. The tip of a round brush defines the shapes of the eye sockets more precisely with raw umber, raw sienna, a little Venetian red, and white, and then moves downward to sharpen the underside of the mouth and the lips with this same mixture. The lines of the chin and jaw are sharpened too. Notice how the warm tones of the cheeks and lower lip now blend softly into the surrounding skin. A small brush begins to pick out individual locks of hair with raw umber, raw sienna, and white. A few strokes of cobalt blue, alizarin crimson, and white enrich the background and define the shoulders.

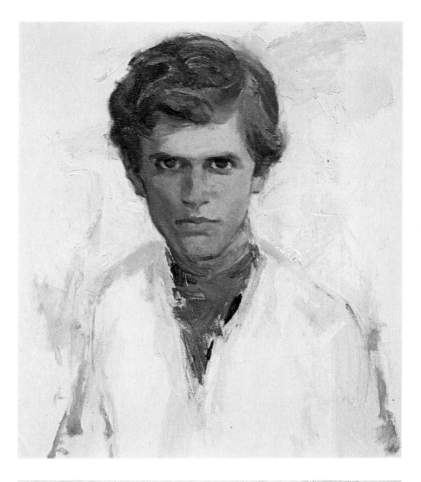

Step 10. Adding still more white to the original flesh mixture, a small bristle brush builds up the lights on the forehead, the upper lip, and the very top of the cheek on the lighted side of the face. At the same time another flat brush enriches the shadows and the halftones with a warmer flesh mixture that contains more Venetian red and raw sienna. Thus the lights become brighter, while the shadows and halftones become darker, warmer, and richer. The tip of a round brush sharpens the lines of the eyes and adds the pupils with ultramarine blue and burnt umber. A round brush adds highlights to the eyes, the tip of the nose, and the lower lip.

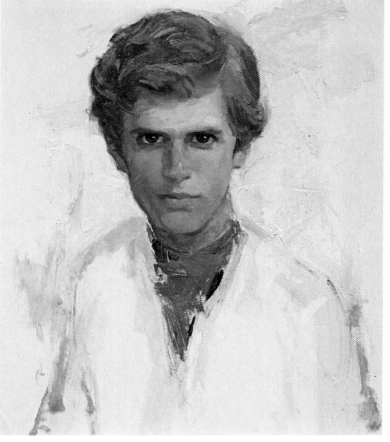

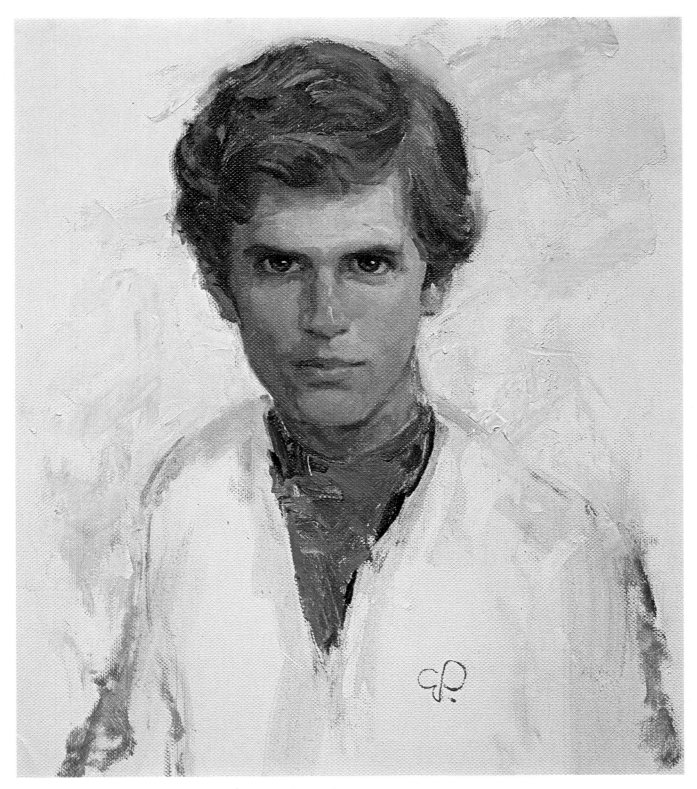

Step 11. A small round brush continues to darken and sharpen such details as the eyebrows, the nostrils, the dark line of the lips, and the shadow beneath the lower lip. More highlights are added to the nose, lips, and ear with pure white tinted with a little flesh tone. A bristle brush picks out more clusters of hair with raw umber, raw sienna, and white. A single dark stroke of ultramarine blue and raw umber defines the shadowy edge of the collar.

Step 1. A big bristle brush tones the canvas with raw umber and turpentine, darkening the lower area to suggest the sitter's dress. A round softhair brush scrubs in the curving top of the sitter's hair and the straight lines of the hair hanging down on either side of the head. Then the tip of the brush draws the oval shape of the face and the lines of the neck and shoulder. After placing a vertical center line, the brush draws horizontal lines to locate the features and adds a single dark touch for one eye.

Step 2. The tip of the round brush adds the dark patches of the eyes, the dark nostrils, and the dark corners of the mouth. The brush also sharpens the shapes of the cheeks, jaw, and chin. A cloth wipes away some of the excess guidelines.

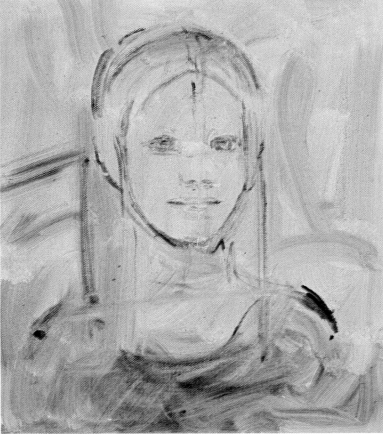

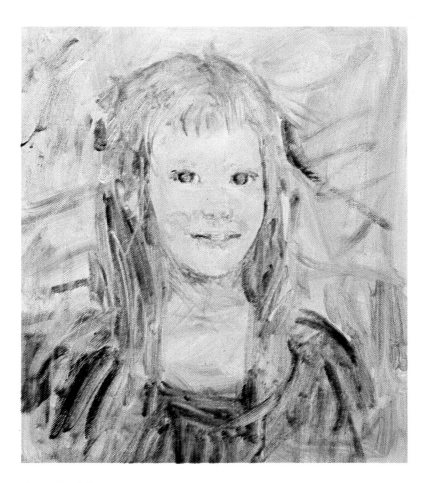

Step 3. A rag wipes away the lighted areas of the face and eliminates the last remaining guidelines. The tip of a round brush draws the shapes of the eyes more precisely and places the darks of the irises. There's no strong pattern of lights and shadows, but the brush indicates some delicate tones between the eyes, along the undersides of the cheeks and nose, and beneath the chin. A bristle brush suggests the tone of the hair and darkens the dress. The entire preliminary brush drawing is executed in raw umber and turpentine.

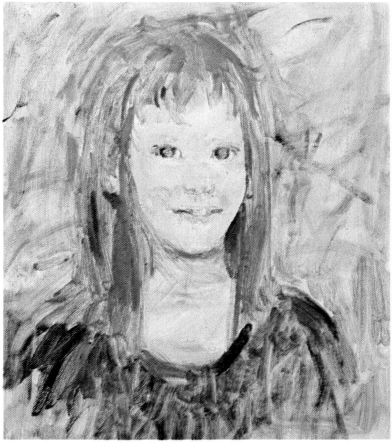

Step 4. A bristle brush begins to suggest the color of the hair with raw umber, raw sienna, Venetian red, and white, diluted with lots of painting medium so the paint is still fairly thin. The background tone is suggested with a few strokes of ultramarine blue, viridian, raw umber, and white. The green dress, which will contrast so nicely with the sitter's red hair and pink skin, is begun with viridian, burnt umber, and white.

Step 5. A small brush fills the dark irises with cobalt blue, a little raw umber, and white. The darks between the lips are raw umber, Venetian red, and white. A big bristle brush begins to cover the face with the palest flesh tones—a mixture of raw umber and lots of white, warmed with the slightest hint of cadmium red and alizarin crimson. The darker tones between the eyes and beneath the cheeks obviously contain less white. Work continues on the background and dress.

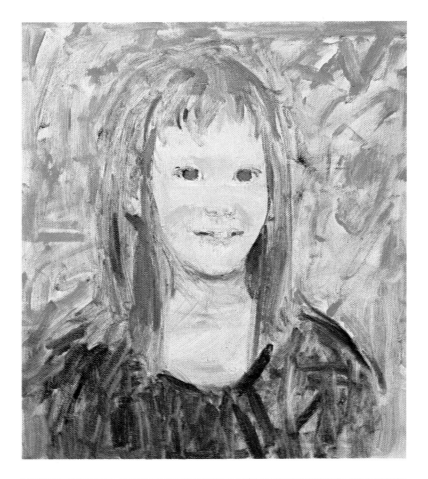

Step 6. The bristle brush continues to lay in the flesh tones with the same mixture, which gradually grows darker on one side of the forehead as well as the cheeks, jaw, and chin. A little more raw umber is added for the shadow on the neck; the skin below is the same pale mixture that appears on the forehead. An extra touch of cadmium red is added for the lips, but the color is still pale, soft, and natural. Now the face is completely covered with lights, halftones, and shadows, all of which are extremely pale.

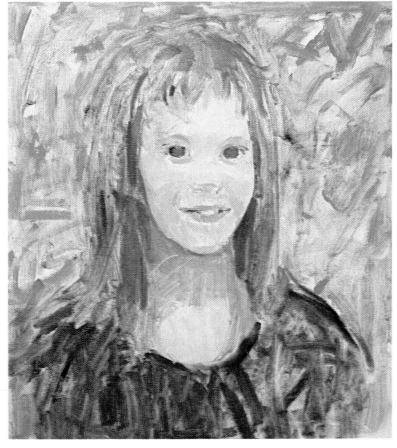

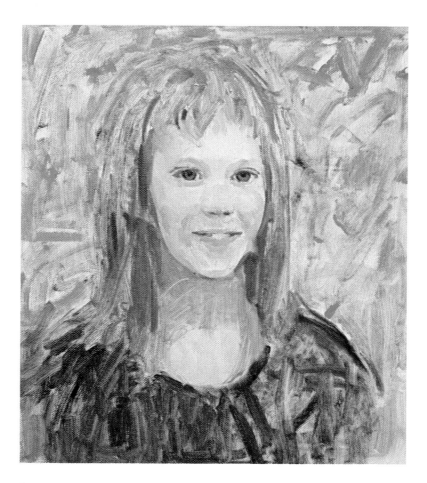

Step 7. The tip of a round brush defines the dark lines of the eyelids with raw umber, raw sienna, a touch of Venetian red, and white. The dark lines around the irises and the darks of the pupils are carefully drawn with cobalt blue and raw umber. The whites of the eyes are painted with a very pale version of the flesh mixture. The nostrils are sharpened with the same mixture that's used for the lines of the eyelids. Adding a little more cadmium red and alizarin crimson to the flesh mixture, a small bristle brush begins to darken the eye sockets, nose, cheeks, and chin.

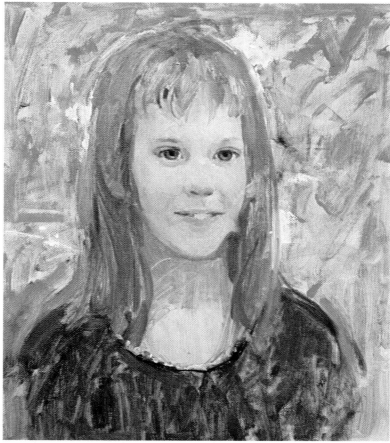

Step 8. A flat softhair brush starts to blend the tones to create softer transitions between lights, halftones, and shadows. Compare Steps 7 and 8 to see how the tones on the forehead, cheeks, nose, and chin flow softly together now. A small brush also darkens the underside of the nose. The teeth are not painted with pure white, but with a very pale version of the flesh mixture, similar to the tone used to paint the whites of the eyes. A big bristle brush goes over the hair with thicker strokes of raw umber, raw sienna, Venetian red, and white, which grow darker and brighter toward the bottom. The tone of the dress is solidified with more strokes of viridian, burnt umber, and white.

Step 9. Adding just a little more white to the pale flesh mixture, a flat brush brightens the lightest planes of the forehead, cheeks, nose, upper lip, chin, and chest. Another flat brush strengthens the darks ever so slightly—you can see this on the shadowy undersides of the cheeks—and blends the shadow on the neck. A small round brush sharpens the lines of the eyes and adds highlights to the pupils with pure white tinted with a whisper of cobalt blue. The lighted top of the hair is painted with quick, ragged strokes of raw umber, cobalt blue, a little Venetian red, and lots of white; this mixture is carried downward over the hair on the forehead. The tone of the hair is warmed with strokes of raw sienna, a little cadmium yellow, and white. Work continues on the background and on the dress.

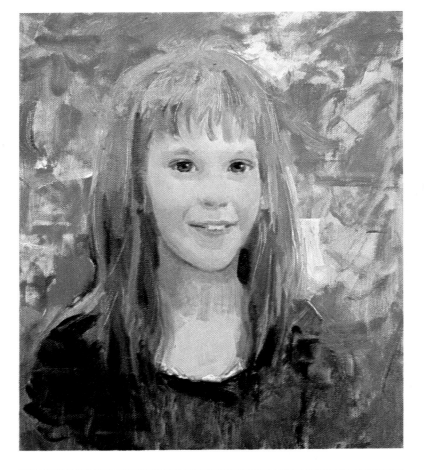

Step 10. The artist begins to concentrate on the smaller forms and details. The tip of a round brush adds more strands of hair—and the sharp end of the brush handle scratches some bright lines into the wet color. The eye sockets, cheeks, and chin are darkened just a little more. The tip of the round brush adds some freckles to the face and chest with raw umber, raw sienna, and white. A dimple is added to one cheek. By now the background and dress are finished. The darks of the dress are viridian and burnt umber, with no white.

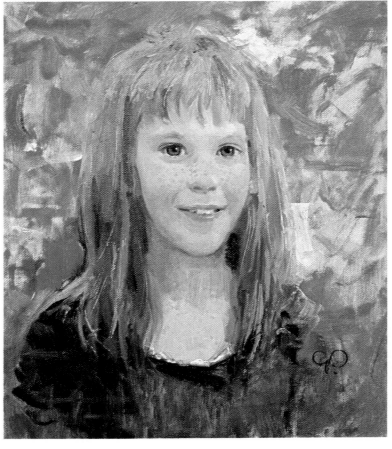

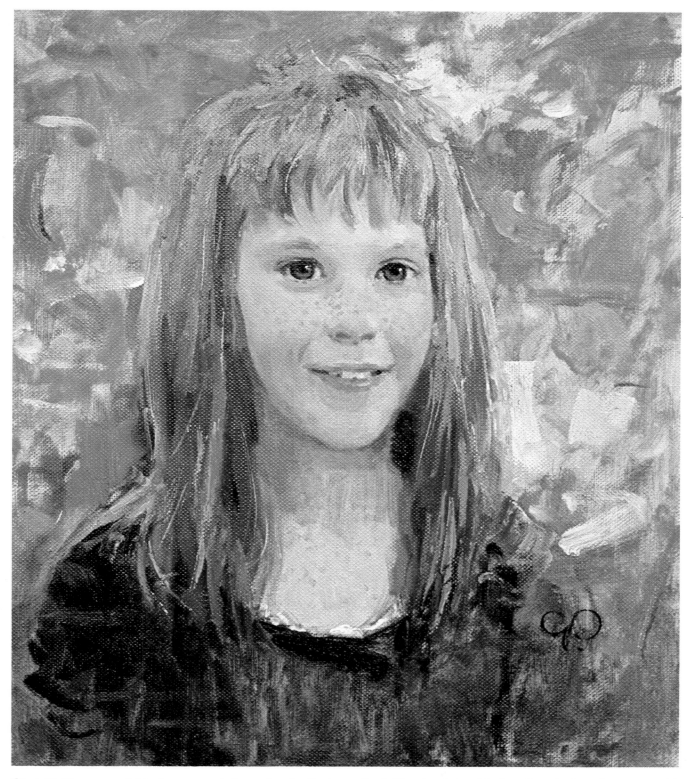

Step 11. The tones of this face are so delicate that the final touches are almost invisible, but they're important as always. The tip of a round brush darkens the shadow lines that are cast over the eyes by the upper lids. A flat softhair brush blurs the edges where the dark tone of the lips meets the surrounding skin. (Always avoid a harsh line around the lips!) The tip of the chin is softened where it merges with the shadow beneath. More strokes of raw sienna, cadmium yellow, and white brighten the hair—and a little hair tone is blended into the background. The corners of the mouth are darkened to accentuate the brightness of the sitter's teeth. A few more freckles are added—and the portrait is complete.

DEMONSTRATION 4. BLOND GIRL

Step 1. Because the finished picture will be generally pale, only the area of the head is toned with cobalt blue, a touch of raw umber, and turpentine. Then a clean corner of the rag wipes away the lighted areas of the face, and the preliminary brush drawing is executed with the same mixture with less turpentine. The brush drawing suggests the wide, loose shape of the hair, the contours of the face, the darks of the eyes, the big shadow that runs down the side of the head and neck, and the small shadows that define the shapes of the features.

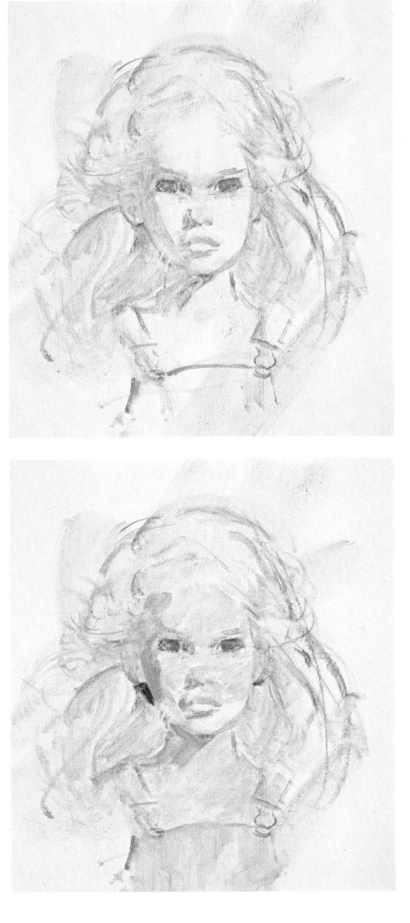

Step 2. A bristle brush paints the big shadows on the side of the face and neck with raw umber and white warmed with a touch of cadmium red and then subdued with a hint of cobalt blue. This same mixture is placed in the eyes and in the shadows of the lips. The lighted planes of the face, neck, and chest are painted with raw umber, white, and a touch of cadmium orange. A wisp of cadmium red is added to this mixture for the warm tone on the cheeks and nose. More white is added to the shadow tone to paint the dress. At this stage the mixtures contain a great deal of painting medium, and the color is applied very thinly.

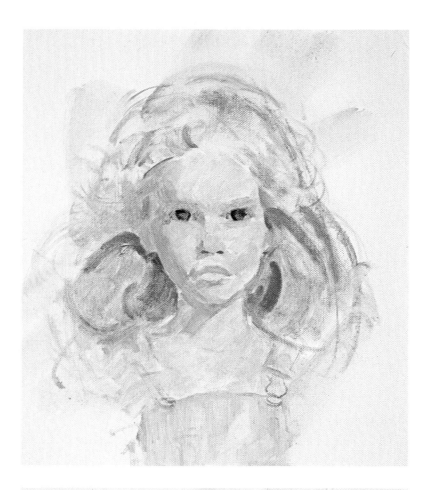

Step 3. A big bristle brush surrounds the face with the darker tone of the hair—a mixture of raw umber, raw sienna, and white, with less white in the darker areas that surround the lower face. Another bristle brush gradually builds up the color on the face. First the shadow tone on the side of the face is completed and the shadows are strengthened within the eye sockets, on the side of the nose, and around the mouth and chin. Then more color is added to the lighted areas of the face. Warmer, richer tones—containing a little more cadmium red and cadmium orange—appear on the nose, cheeks, and chin. The dark edges of the irises are defined by a small round brush that carries a mixture of cobalt blue and raw umber.

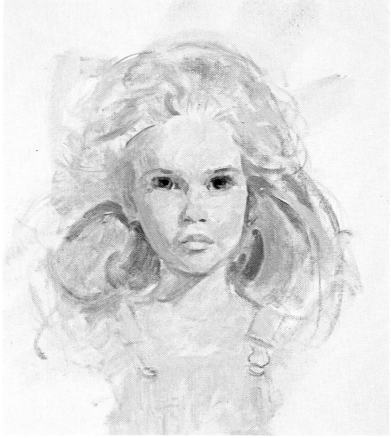

Step 4. The small round brush continues to sharpen the features. The shadows around the eyes are darkened with the same mixture that appears in the hair: raw umber, raw sienna, and white, with the slightest touch of cobalt blue. The corners of the eyes are darkened, and the eyebrows are brushed in. This same mixture darkens the shadow at the side of the nose, defines the lines between the lips, darkens the shadow beneath the lower lip, and darkens the shadow under the chin to bring the head forward. A stroke of this mixture sharpens the edge of the cheek at the right. A few more strands of hair are added above the forehead.

Step 5. A flat softhair brush starts to blend the brushwork on the face to create smoother, more continuous tones. The brush adds more white to the flesh mixture and begins to build up the lights on the forehead and the bridge of the nose. As the brush blends and smoothes the shadow side of the face, it darkens the inner edge of the shadow with a little more raw umber, cobalt blue, and white. The shadow on the neck is darkened with this mixture. The tip of a round brush sharpens the lines of the eyes, nose, lips, and chin with raw umber, raw sienna, a touch of Venetian red, and white. Work continues on the hair, which is now fuller and more distinct. A few broad strokes of cobalt blue, raw umber, and white are added to the background.

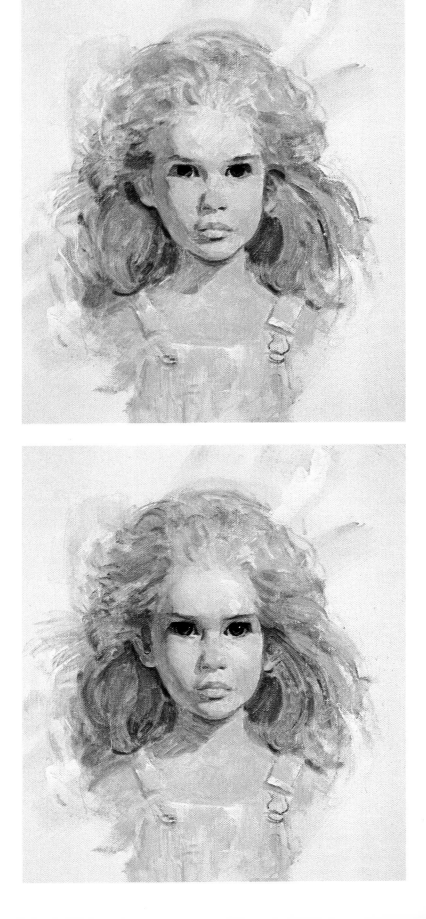

Step 6. The tip of a round brush concentrates on the eyes, which are the darkest notes in the painting. The whites of the eyes are painted with a very pale version of the flesh mixture. The dark edges of the irises and the dark notes of the pupils are carefully drawn with a mixture of raw umber and cobalt blue, which is also used to draw the shadowy lines beneath the upper lids. The highlights on the pupils are placed with pure white tinted with flesh tone. A little more cadmium red is blended into the lips, and the forms are more precisely drawn. The shapes of the earlobes are sharpened with lines of the hair mixture—and the details of the hair begin to appear.

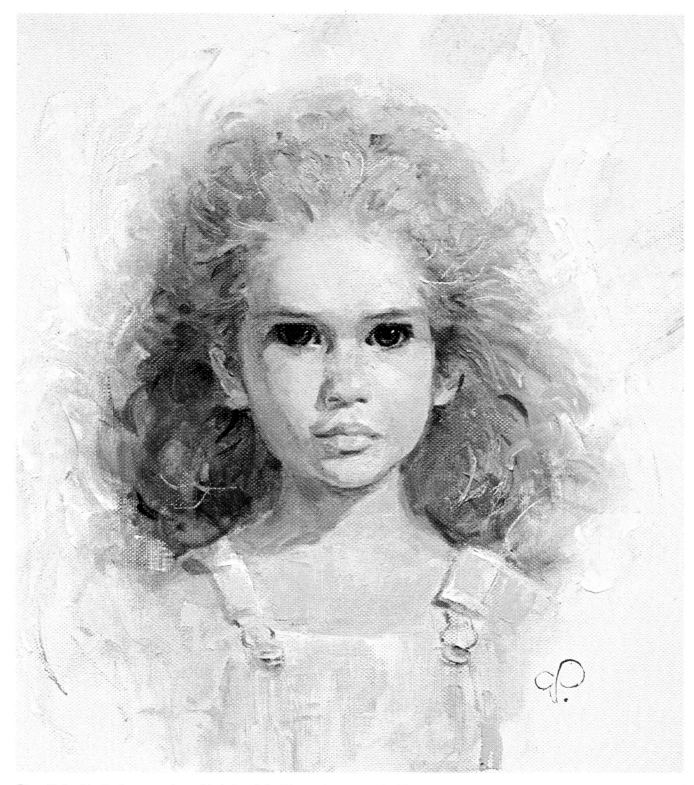

Step 7. In this final stage a flat softhair brush builds up the lights on the forehead, cheeks, nose, chin, and chest with the original flesh mixture and still more white. The nostrils and the line between the lips are sharpened. Subtle highlights are added just above the eyebrows, on the bridge and tip of the nose, and on the lips and chin. The background is completed with very pale strokes of cobalt blue, raw umber, and white—and this tone is blended into the lighter areas of the hair, which now merge softly with the background. Some of this mixture is blended into the shadowy hair around the neck. A small brush picks out individual strands of light and dark hair; the lighter strands are scratched away by the pointed end of the brush handle.

Step 1. The canvas is toned with a pale wash of cobalt blue and turpentine. A round softhair brush draws the head with the same mixture, and then a clean cloth wipes away the lighted areas of the skin. The shadow side of the face is only a bit darker than the lighted side. There are also very pale shadows within the eye sockets, beneath the nose, and within the lips. The brush indicates only one very strong shadow—beneath the chin. Then a big bristle brush surrounds the head with a much darker tone and carries this tone over the sitter's jacket. A rag wipes away the pale tone of the sweater inside the jacket.

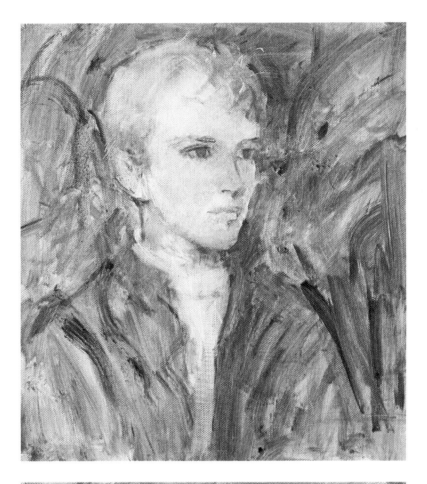

Step 2. The round brush defines the dark edges of the forms on the shadow side of the face— the brow, cheek, nose, lips, jaw, chin, and neck. At the same time the brush darkens the shadow lines of the upper eyelids and the underside of the earlobe. These darks are a mixture of raw umber, Venetian red, cadmium orange, and a little white. Then a flat bristle brush adds a great deal of white and painting medium to this same mixture and begins work on the lighted areas of the face. The cheek contains slightly more Venetian red. The first touches of background color are placed around the head—a mixture of cobalt blue, raw umber, and white.

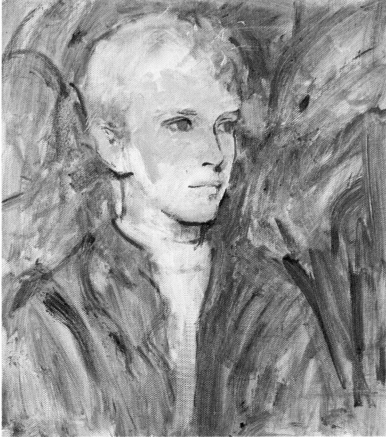

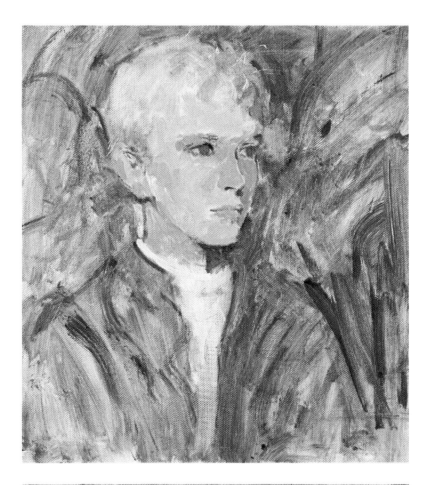

Step 3. Working with the same mixture of raw umber, Venetian red, cadmium orange, and white, the flat bristle brush covers the entire face and neck. The shadow side of the face, the eye sockets, the nose, and the lips contain less white and just a bit more Venetian red. Notice that the lower half of the face is distinctly darker and warmer than the forehead. The neck is darker still. The dark shadow beneath the chin is the same mixture used for the darks in Step 3. A few strokes of raw umber, a hint of cadmium yellow, and white suggest the color of the sweater.

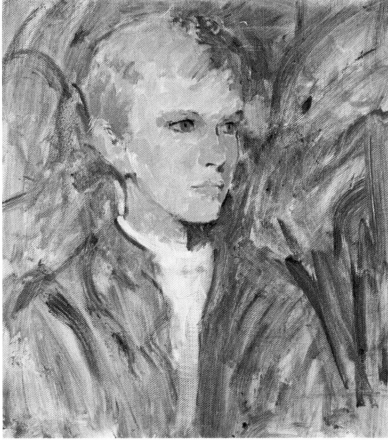

Step 4. A large bristle brush starts to indicate the tones of the hair with raw umber, raw sienna, and white. More white is added to the lighted area of the hair. The short strokes suggest the curly texture that will become more apparent later on. The darks of the irises are strengthened with cobalt blue and white. The pupils are located with a single touch of cobalt blue and raw umber.

Step 5. A big bristle brush darkens the entire background with rough, irregular strokes of cobalt blue, raw umber, and white. These strokes don't completely cover the underlying blue tone, which still shines through. The same brush covers the jacket with a dark mixture of cobalt blue and raw umber; there's a little white in the lighted areas, but no white in the shadows. The sweater is brushed in with strokes of raw umber, cadmium yellow, and white, with some burnt umber in the shadows. A smaller bristle brush begins to build up the tones of the hair with the same mixtures that first appeared in Step 4. And the flat bristle brush begins to blend the strokes of the face into smoother, more continuous tones. A round brush adds more darks to the shadow side of the face.

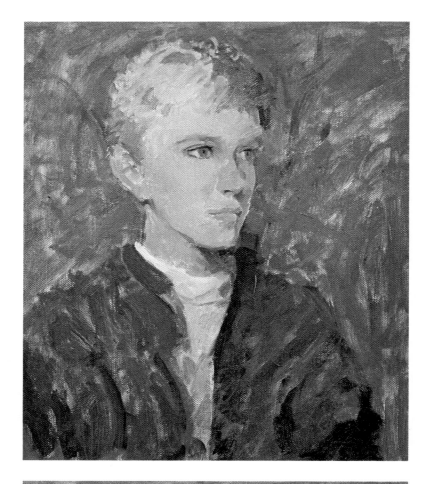

Step 6. A small bristle brush adds more white to the basic flesh mixture and builds up the lighted areas with thicker color. You can see that the forehead, the cheeks, the upper lip, and the chin are more luminous than Step 5. Some of this light tone is also blended into the neck. A small bristle brush sharpens the shapes of the nose and the lips. The tip of a round brush strengthens the dark lines of the upper eyelids.

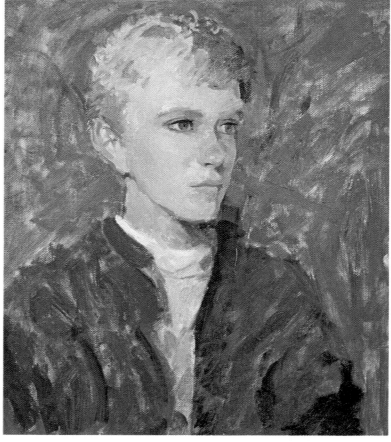

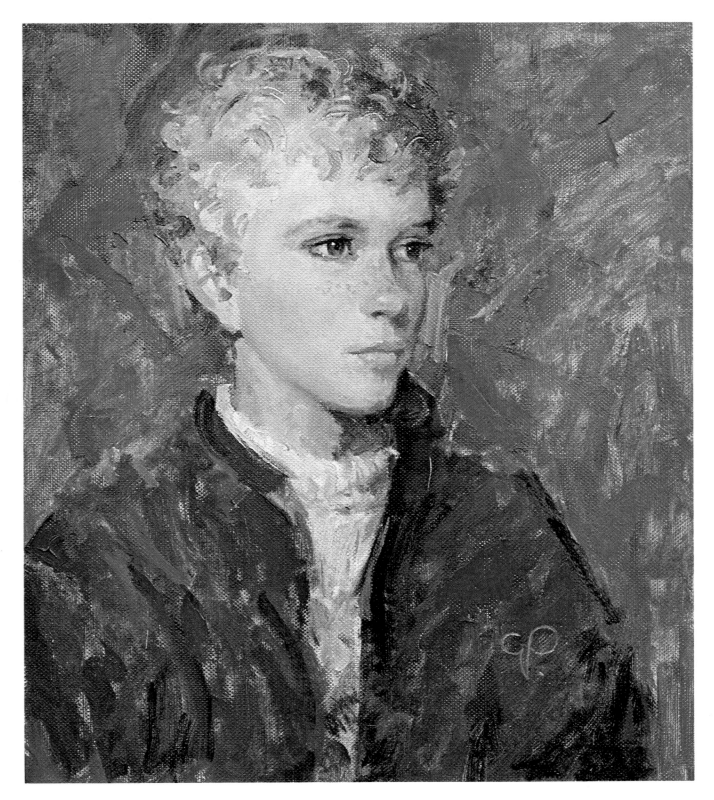

Step 7. A flat softhair brush continues to blend the tones of the face, which are now soft and smooth. The brushwork on the neck remains a bit rougher. The tip of a round brush darkens the lines of the upper eyelids, and strengthens the pupils with cobalt blue and raw umber, and then places highlights on the pupils with pure white tinted with the slightest touch of cobalt blue. A few more darks are blended into the shadow side of the face with the original skin mix-ture, but with more raw umber and Venetian red added. A round brush adds some freckles with this mixture. The eyebrows are completed with soft, blurry strokes of the same mixture that appears in the hair: raw umber, raw sienna, and white. Dark curls are added to the hair with this mixture. More white is added for the brighter curls. The short, curving brushstrokes emphasize the lively texture of the blond hair.

Step 1. A rag tones the canvas with raw sienna, a little ultramarine blue, and turpentine. The preliminary brush drawing is executed with this same mixture, emphasizing the strong darks of the sitter's hair and eyes. The brush drawing also emphasizes the dark shadow on the side of the nose and indicates the shadow sides of the forehead, cheek, jaw, chin, and neck. A few dark strokes beneath the chin suggest the dark tone of the bow tie. A rag wipes away some tone from the lighted planes of the face.

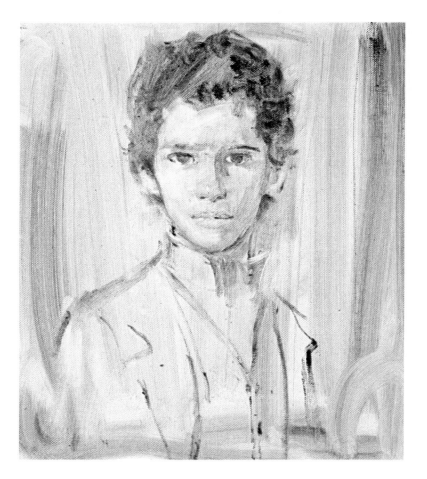

Step 2. A big bristle brush covers the background with broad strokes of ultramarine blue, burnt umber, and white, leaving some gaps for the warm undertone of the canvas to shine through. The sitter's dense, curly hair is begun with short strokes of burnt umber, ivory black, a touch of alizarin crimson, and some white. There's more black in the shadow strokes. The shadow side of the face and nose as well as the dark ear are painted with raw umber, Venetian red, a little raw sienna, and white. A pointed brush sharpens the lines of the features with this mixture. Then a bristle brush adds more white to this mixture to paint the lighted planes of the face. The shirt and bow tie are painted with cobalt blue, a little alizarin crimson, and lots of white—with less white in the bow tie, of course. More alizarin crimson is added to this mixture for the dots on the bow tie.

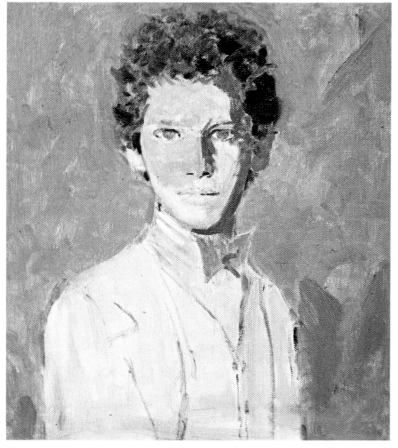

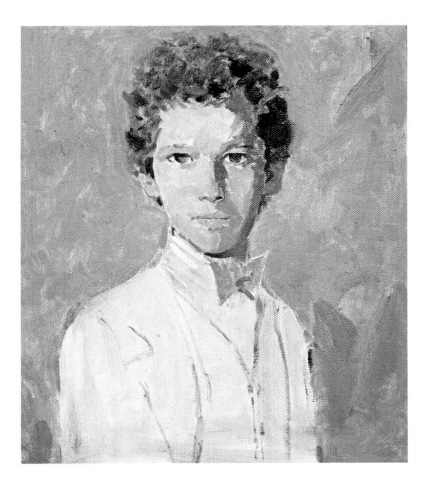

Step 3. A big bristle brush covers the lighted areas of the face with various mixtures of raw umber, Venetian red, raw sienna, and white—gradually darkening the strokes as the brush moves downward over the lower half of the face. The darks are strengthened on the shadow sides of the mouth and chin. Halftones are added within the eye sockets, around the eyes, and where the light meets the shadow on the dark side of the face. The eyes are darkened with burnt umber, ivory black, and white. The tip of a round brush sharpens the lines of the eyelids, nose, and lips, adding the dark hollow of the ear that's in shadow. A single dark stroke beneath the chin makes the chin come forward.

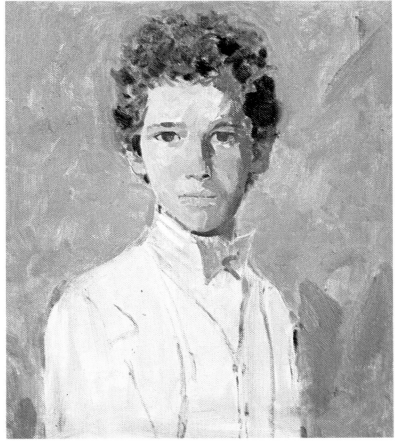

Step 4. A flat brush begins to blend the tones of the face. You can see that the lighted cheek and jaw are now smoother where the brushstrokes have begun to merge. The tip of a round brush continues to darken the eyes with burnt umber and ivory black. The brush then darkens the lines of the upper lids and the corners of the eyes with this mixture, adding a few strokes to strengthen the eyebrows. Notice that the lighted cheek is distinctly paler than the lighted patch of the cheek on the shadow side of the face. In the same way the eye socket on the lighted side of the face is paler than the eye socket on the shadow side.

Step 5. A flat brush continues to blend the tones of the face: the rough brushwork gradually melts away into smooth, continuous tones. A small bristle brush darkens the hair with ivory black, burnt umber, and a little alizarin crimson, adding some white to the lighted areas. Now the artist is concentrating on the smaller forms. The whites of the eyes are painted with pure white tinted with a little flesh tone. The pupils are added with burnt umber and ivory black. The tip of a round brush carefully draws the lights and shadows of the valley that leads from the nose to the upper lip. The lips are painted more precisely, adding an extra touch of Venetian red to the shadowy flesh mixture.

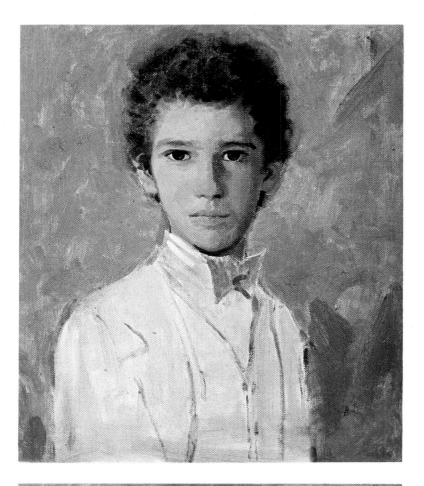

Step 6. Adding more white to the palest flesh tone, a bristle brush builds up the lighted areas of the forehead, cheek, nose, and chin. The tip of a round brush picks up this mixture to place the highlights on the eyes. A small bristle brush moves down the dark side of the nose, hardening the shape of the shadow to emphasize the bony structure of the bridge and the shape of the tip. A big bristle brush covers the suit with raw sienna, a little raw umber, and lots of white. The shadows on the suit contain somewhat more raw umber.

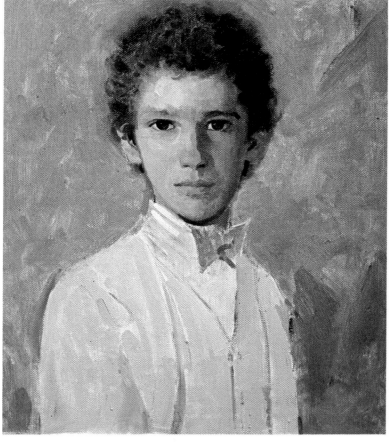

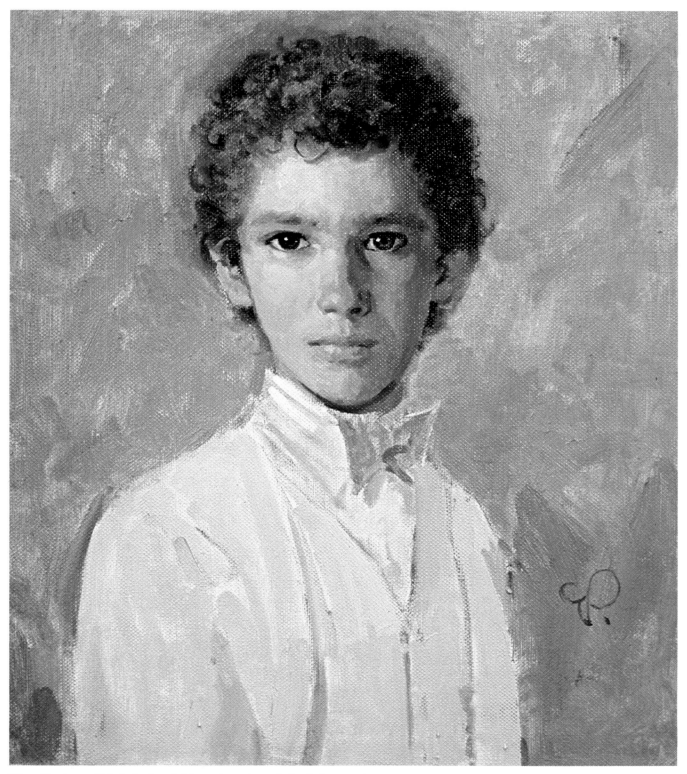

Step 7. A small bristle brush blurs the edge of the hair where it melts away into the background and then adds individual curls with quick dabs of the tip of the brush carrying burnt umber, ivory black, a little alizarin crimson, and white. The tip of a round brush adds a few individual strands of hair and then darkens the lines of the eyes with this same mixture. The round brush blurs the eyebrow on the shadow side of the face, draws a shadow line next to the nostril, and darkens the corners of the lips and the shadow beneath the lower lip. The last touches are the thick highlights—white and just a little flesh tone—beside the bridge of the nose, on the tip of the nose, beside and beneath the lighted nostrils, and on the lower lip. One more highlight is added to the lower eyelid on the lighted side of the face.

Step 1. A rag tones the canvas with raw umber and turpentine warmed with just a touch of burnt umber. A small bristle brush begins the preliminary drawing with rough masses of tone for the hair, the eye sockets, the shadowy underside of the nose, the lips, and the big shadow that runs down the side of the face and under the chin. A cloth wipes away the lighted areas on the front of the face. The artist works with broad patches of tone to emphasize the strong pattern of light and shadow on this head.

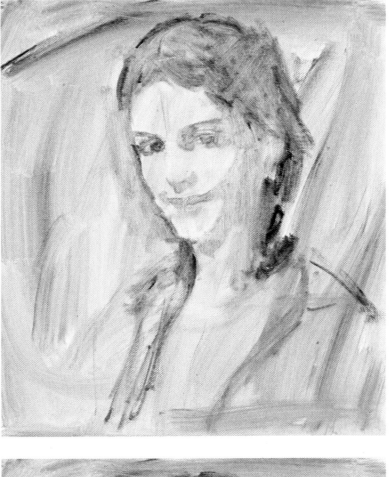

Step 2. The tip of a round softhair brush draws the contours of the brow, cheek, jaw, chin, and neck more precisely. Then the brush defines the features, adding sharp lines for the eyebrows, eyelids, nostrils, and lips. A flat bristle brush strengthens the shadow on the cheek, jaw, and neck, and then darkens the hair and indicates the tone of the sitter's coat. The entire brush drawing is executed in raw umber, a little burnt umber, and turpentine.

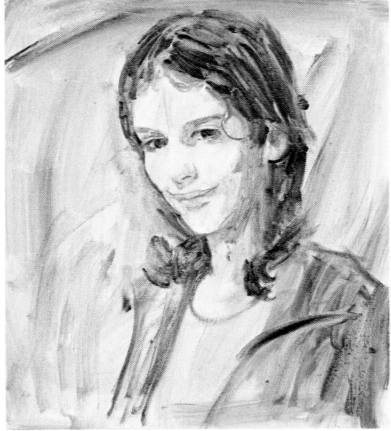

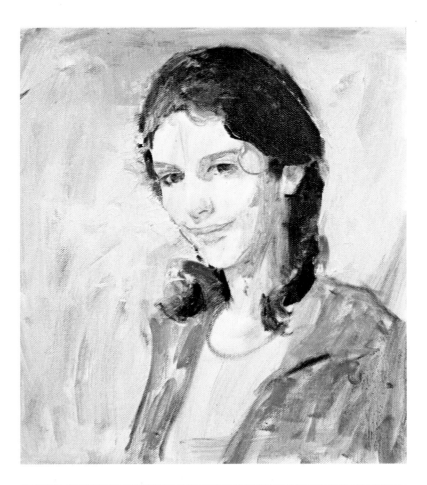

Step 3. A big bristle brush covers the hair with a solid tone of burnt umber, ivory black, a little alizarin crimson, and a touch of white to brighten the color. A big brush covers the background with loose strokes of alizarin crimson, cobalt blue, raw sienna, and lots of white. The warm tone of the coat is suggested with casual strokes of alizarin crimson, burnt umber, and white.

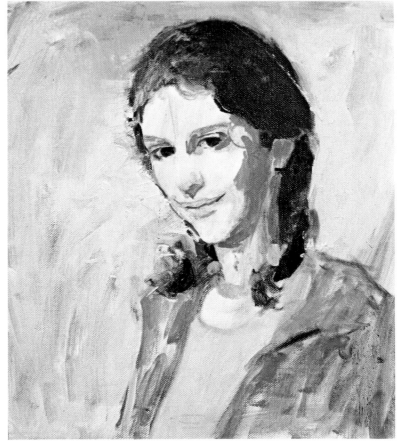

Step 4. A bristle brush paints the strong shadow on the side of the face with raw umber, raw sienna, just a little Venetian red, and white. This tone moves around under the chin and re-appears on the ear and neck. A round brush picks up this tone to darken the eye sockets, the underside of the nose, and the line of the lips.

Step 5. A big bristle brush covers the brightly lit forehead with raw umber, raw sienna, Venetian red, a speck of alizarin crimson, and plenty of white. Adding more Venetian red and alizarin crimson to this mixture, the brush moves down over the cheeks and nose, which are darker and warmer than the forehead, as usual. A few strokes of flesh tone are added to the chest, and then the blouse is painted with raw sienna, raw umber, and white.

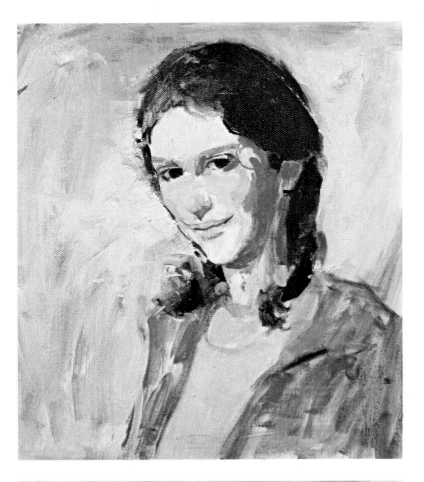

Step 6. A big bristle brush completes the job of covering the lighted area of the face with raw umber, raw sienna, Venetian red, a touch of alizarin crimson, and white. A little more raw umber and Venetian red are added to this mixture to paint the halftones that appear in the eye sockets, on the side of the nose, and along the edge of the big shadow on the side of the face. The basic mixture is heightened with a little extra alizarin crimson to paint the lips. As always the upper lip is darker because it's in shadow, while the lower lip is brighter because it turns upward to catch the light.

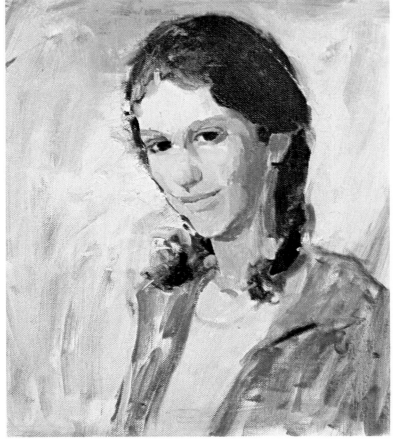

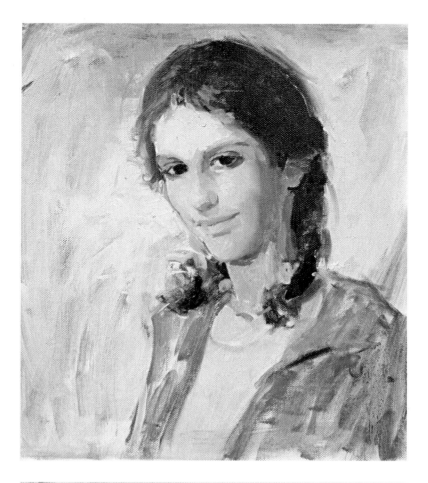

Step 7. A flat brush blends the lights, halftones, and shadows on the face. The individual brushstrokes, which stood out so clearly in Step 6, now fuse into soft, continuous tones. The tip of a round brush darkens the eyes with burnt umber and ivory black, sharpening the lines of the upper lids and strengthening the eyebrows. An extra touch of Venetian red is blended into the halftone where the light and shadow meet on the side of the face. Pale, delicate shadows are placed beneath the nose and lower lip.

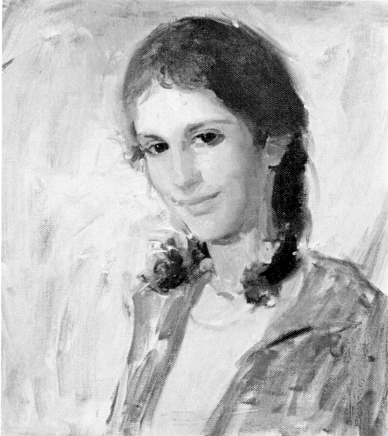

Step 8. The eyes become more lively and expressive as a round brush adds the pupils with ivory black and just a little burnt umber, using the same mixture to darken the edges of the upper eyelids. Tiny highlights are placed on the pupils with pure white tinted with flesh tone. The shadow on the side of the nose and the shape of the underside are strengthened. More white is blended into the hair mixture to soften and blur the lighted side of the hair.

Step 9. Adding more white to the basic flesh mixture of raw umber, raw sienna, and Venetian red, a bristle brush builds up the lights with thick strokes. You can see these strokes on the forehead, beneath the eye and on the cheek at the right, around the mouth, and on the chin. A single stroke indicates the dark hollow of the ear. Then the bright earring is painted with cadmium red, alizarin crimson, a little raw umber, and a touch of white for the highlight. The contour of the hair at the top of the head is sharpened and darkened. The whites of the eyes are painted with a very pale flesh tone, and then the corners of the eyes are darkened with burnt umber and ivory black.

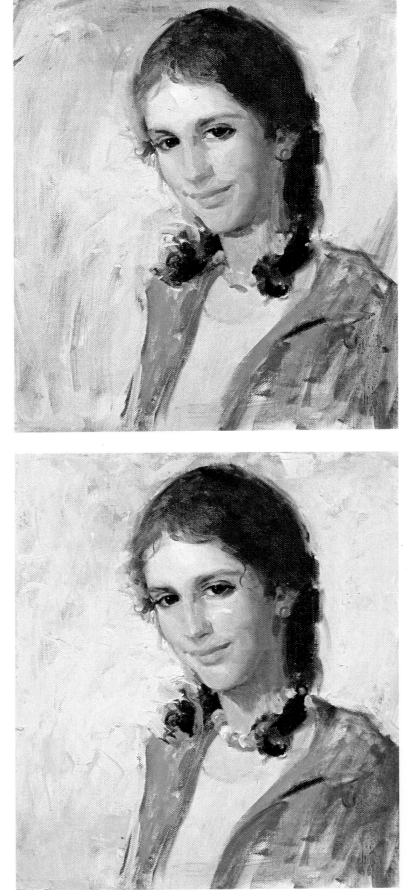

Step 10. A flat softhair brush blends these thick strokes of light—applied in Step 9—into the surrounding flesh tones. You can see this most clearly in the forehead, which is now brighter, smoother, and rounder. A small brush adds highlights of pale flesh tone to the nose and cheek. More Venetian red is added to the shadow mixture to suggest a warm reflected light along the jaw. The background is completed with thick strokes of the original mixture: cobalt blue, alizarin crimson, raw umber, and white. Alongside the forehead, some dark strokes of hair are blurred into the background.

Step 11. The eyebrows and the eyes are darkened with a few final strokes of burnt umber and ivory black. The tip of a round brush uses the same mixture to add a few extra strands of hair. A bristle brush travels around the contour of the hair, blending the dark tone softly into the pale background. More Venetian red is blended into the shadow beneath the jaw, and this bright tone is extended onto the chin. A touch of Venetian red also brightens the hollow of the ear and the underside of the nose. The red beads are painted with the same mixture as the earring, but with a little more white. The other beads are cobalt blue and white. The strokes of the coat are various mixtures of cadmium red, alizarin crimson, burnt umber, and white.

Step 1. This portrait is painted on a gesso panel rather than on canvas. A sheet of hardboard is brushed with several coats of acrylic gesso diluted with water to the consistency of thin cream. The gesso is allowed to dry overnight, and then the surface is toned with a rag dipped in raw umber and turpentine. The preliminary brush drawing is executed with this same mixture. The drawing emphasizes the two strongest darks: the hair and the eyes. A subtle wash of raw umber and turpentine, as thin as watercolor, indicates a shadow that's cast by the hair over the forehead and the bridge of the nose. This same soft tone appears on the shadow side of the face to the left—only slightly darker than the lighted side of the face.

Step 2. The background is covered with knife strokes of cadmium orange, raw umber, and white. A big bristle brush places casual strokes of color on the blouse: cadmium yellow softened with raw sienna, raw umber, and white. Another bristle brush begins work on the hair with raw umber, ultramarine blue, and a little white at the top; the brush doesn't carry too much color, so the bristles make a ragged, scrubby stroke that suggests the wispy texture of the hair. A round brush places the darks of the irises with burnt umber and ivory black. The first strokes of flesh tone are raw umber, raw sienna, a little Venetian red, and white, diluted with painting medium.

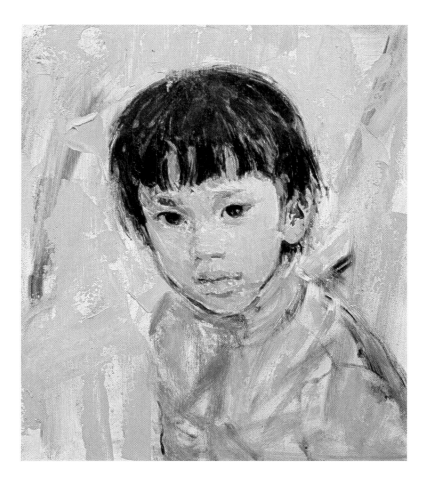

Step 3. A bristle brush finishes the job of covering the face with various mixtures of raw umber, raw sienna, Venetian red, a speck of cadmium red, and white. The strokes contain more raw sienna and raw umber on the shadow side of the face, between the eyes, on the side of the nose, and in the shadowy areas beneath the nose and lower lip. A bit more Venetian red is added to the lighted areas of the cheeks. Notice how extra touches of Venetian red and cadmium red warm the chin, nostrils, lips, and ear. The whites of the eyes are painted with white tinted with raw umber. The dark irises are warmed with tiny touches of Venetian red and raw sienna.

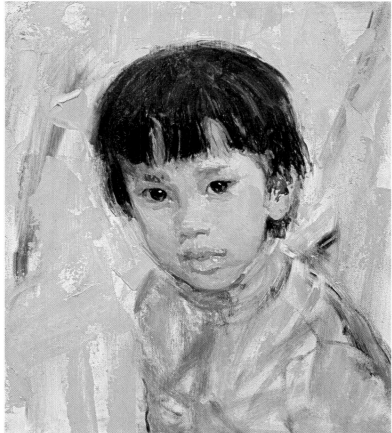

Step 4. A flat softhair brush begins to blend the brushstrokes of the face together to produce a smoother, more delicate tone. The shadows are strengthened in the eye sockets, on the nose and cheek, and alongside the jaw. Blending more Venetian red and cadmium red into the shadowy flesh mixture, a round brush paints the shapes of the lips with curving strokes. The shadow on the forehead is darkened by adding a little more raw umber to the flesh mixture. The shape of the hair is solidified with heavier strokes of ultramarine blue and raw umber. A pointed brush sharpens the lines of the eyes, adds the pupils with this same dark mixture, and then adds tiny highlights with pure white tinted with flesh tone.

Step 5. The painting knife covers the background with thicker strokes of the original mixture: cadmium orange, raw umber, and white. Softhair brushes continue to work on the face, building up the light on the cheeks, upper lip, chin, and earlobe. At the same time the lips are darkened and blended to look warmer and rounder. A flat softhair brush blends the strokes on the forehead, nose, chin, and shadowy cheek. The blended paint has a particularly smooth, delicate character on the smooth surface of the gesso panel, which enhances the tender quality of the little boy's skin.

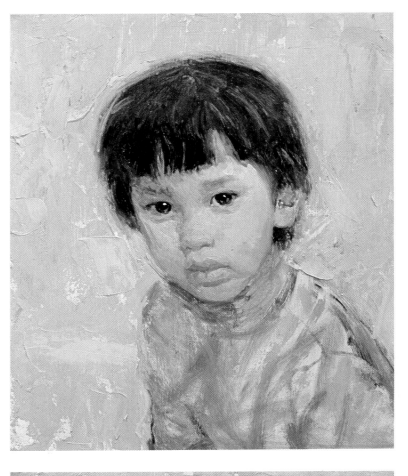

Step 6. The tone of the blouse is enriched with heavier strokes of cadmium yellow, raw sienna, raw umber, and white. The tip of a round brush adds the lighter tones of the hair with raw umber, ultramarine blue, and white, picking out individual strands and blending the edges of the hair softly into the pale background. The tip of a round brush modifies the contour of the shadow side of the face with strokes of warm flesh tone containing more Venetian red. These strokes are blended softly into the skin, leaving a dark edge where the cheek turns away into the shadow. The entire shadow side of the face is darkened slightly and blended more smoothly.

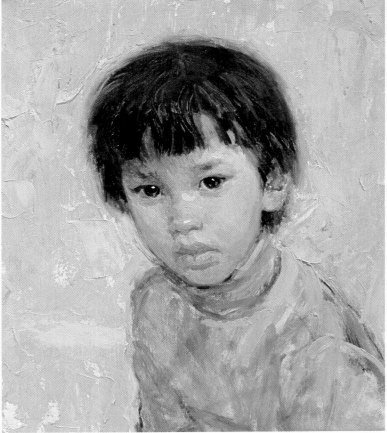

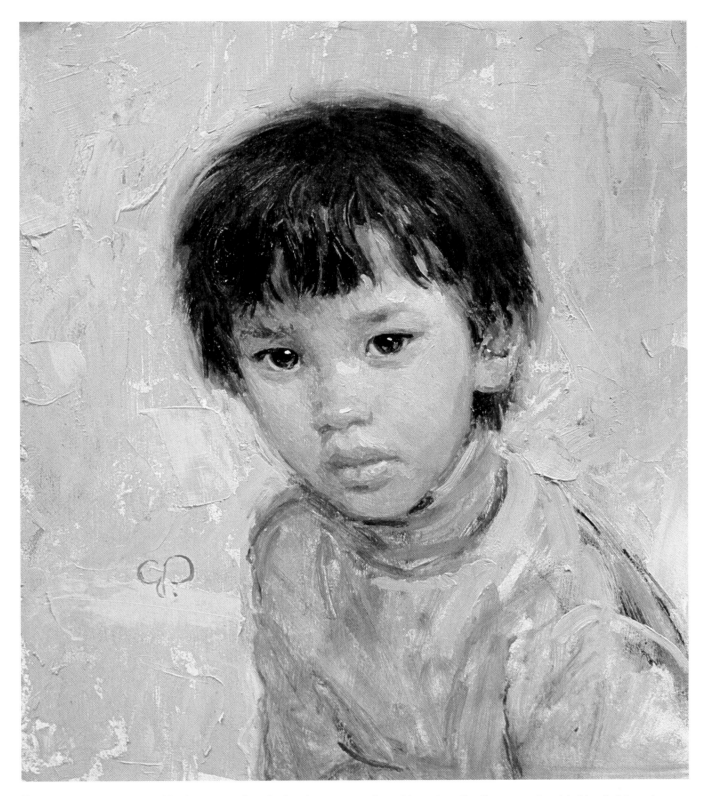

Step 7. Blending more white into the palest flesh mixture, a small brush adds thick touches of light to the brow above the eye on the lighted side of the face, the lighted cheek, the bridge and tip of the nose, just above the upper lip, and the side of the lower lip. The eyebrows and the dark lines of the upper eyelids are the same mixture as the hair: ultramarine blue and raw umber. The dark line on the side of the face in Step 6 has virtually disappeared as it's blended into the tone of the flesh. A few small strokes of flesh tone are carried upward from the forehead into the hair to suggest bright skin shining through the dark locks. On the gesso panel, which lacks the rough weave of canvas, the only texture is the texture of the paint itself—rough where the paint is applied roughly, smooth where the strokes are softly blended.

Step 1. The canvas is toned with burnt umber and turpentine. The warm tone of this mixture already begins to suggest the color of the sitter's skin. You can see where vertical and horizontal guidelines have been brushed over the face and then wiped away as the brush drawing proceeds. The brush indicates the dark shape of the hair, the darks of the eyes, the shadows within the eye sockets, the shadowy underside of the nose, the dark upper lip, and the shadow beneath the lower lip. The shadow side of the face, at the left, is suggested with a fluid wash of burnt umber and turpentine, while the lighted side of the face is wiped away with a cloth.

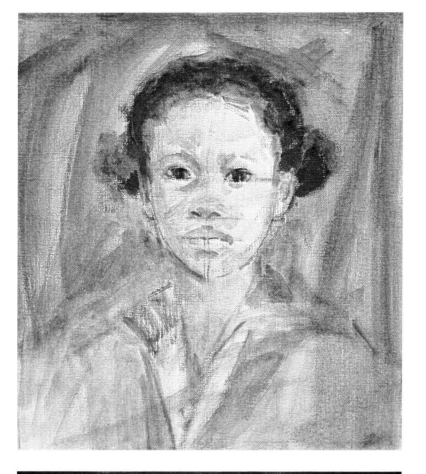

Step 2. A large bristle brush covers the face with several different mixtures of raw umber, cadmium orange, Venetian red, and white—with a touch of ivory black in the strongest darks. The warm, dark background is painted with thick strokes of burnt umber, alizarin crimson, and ivory black, plus a touch of white. This same mixture, without the white, darkens the hair and the eyes. At this stage, the colors are all simple, flat shapes that will be blended later on.

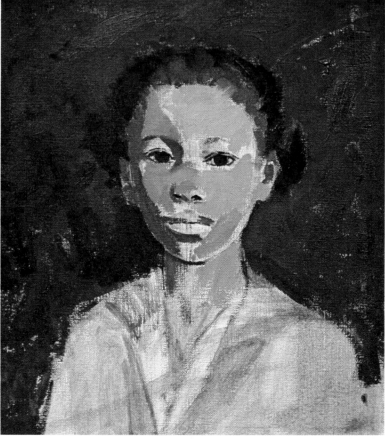

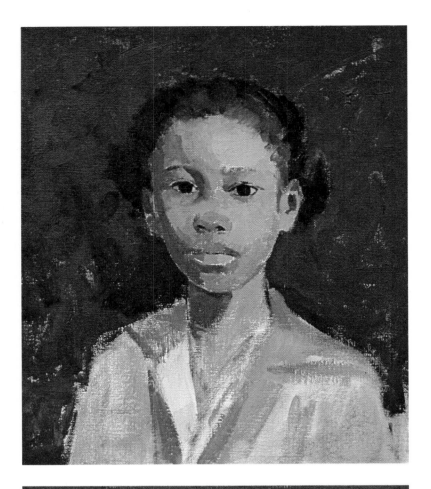

Step 3. The entire face and neck are now covered with flesh tones. The brightest skin tone appears on the forehead on the lighted side of the face. Notice how the jaw darkens as it curves away from the light. The tip of the nose is slightly darker than the bridge. Notice how the rounded eye socket curves from dark to light. Observe how the lower lip is painted as three separate planes of color: dark, halftone, and light. The dress is painted with the same mixtures as the skin, warmed with a little more Venetian red and brightened with more white.

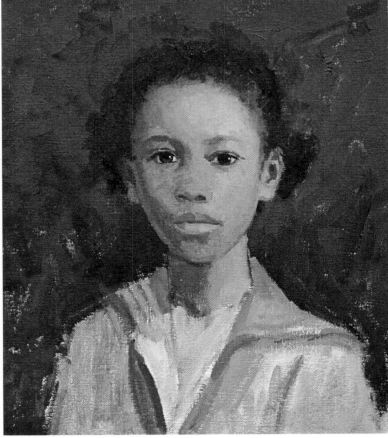

Step 4. Blending more white into the flesh mixture, a bristle brush gradually builds up the lighted area of the forehead, the lighted cheek, the nose, the lower lip, and the lighted side of the neck. Then a flat brush begins to blend all the tones together to make the face look more rounded and lifelike. The eyebrows are darkened. The dark lines of the lids and the dark patches of the pupils are painted with burnt umber and ivory black. The whites of the eyes and the highlights next to the pupils are pure white, tinted with a speck of raw umber.

Step 5. Still more white is added to the palest flesh tone to build up the lights. Until now the skin has looked rather drab, but now it begins to glow as luminous touches are added to the brow, eye sockets, nose, and lips. A small brush darkens the shadow areas of the eye sockets, sharpens the contours of the eyes, draws the nostrils and the underside of the nose more precisely, and blends and softens the lips and chin.

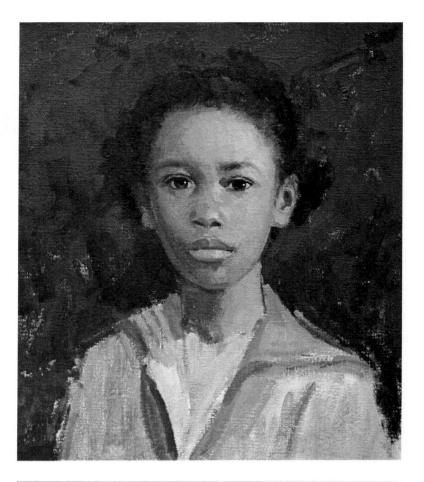

Step 6. Thick touches of light are now added to enrich the lighted sides of the forehead, brow, cheek, nose, and lips. A touch of light is added to the ear on the lighted side of the face. A small round brush darkens the contours of the lips and strengthens the tone of the eyebrows. The hair is darkened with burnt umber and ivory black, and then the edges of the hair are blurred softly into the dark background.

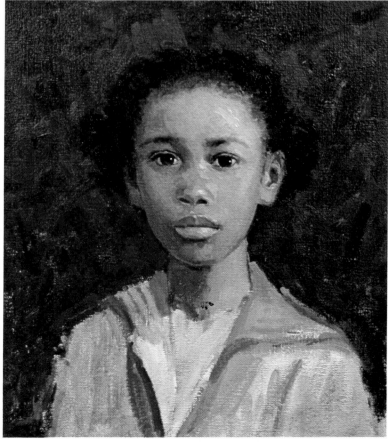

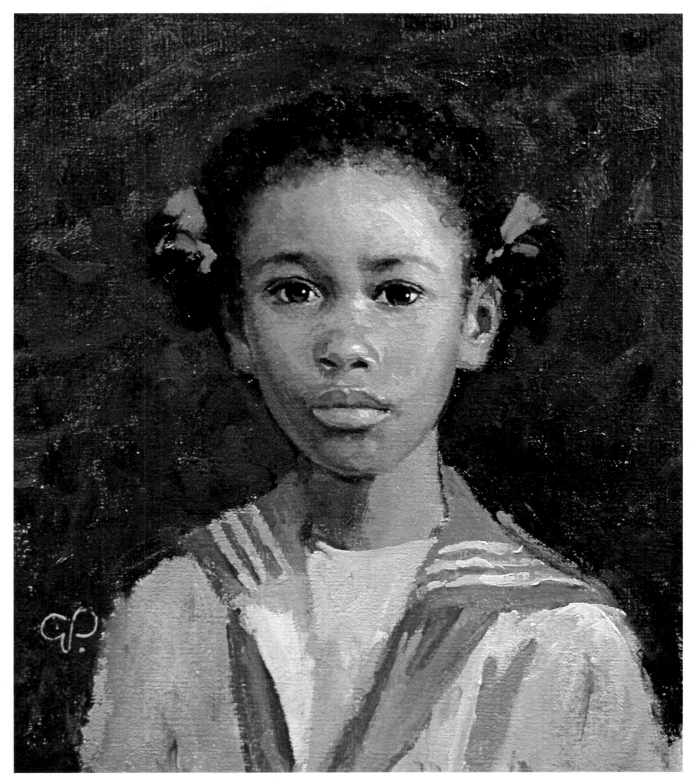

Step 7. In the final stage touches of Venetian red and cadmium orange are blended into the shadow mixture to add subtle, warm notes to the shadow side of the face. At the same time, cool notes are added to the eye socket and the forehead on the shadow side of the face with ivory black, raw umber, and white. Warm notes are added to the eyes with Venetian red, cadmium orange, and raw umber. A small round brush scribbles some strokes over the hairline to suggest individual curls of hair. The cool shadows on the blouse are ivory black, raw umber, and white. The portrait is completed by a few quick strokes for the ribbons: cadmium orange, burnt umber, Venetian red, and white.

Step 1. A rag tones the canvas with burnt umber diluted with lots of turpentine to a very pale tone. The preliminary brush drawing is also executed in burnt umber diluted with less turpentine. The dark tone of the hair is scrubbed on with a bristle brush and so is the tone of the sweater. A round softhair brush draws the contours of the face and features. Then a bristle brush carries the shadow tone down the dark side of the face and adds a few touches of shadow on the dark sides of the features.

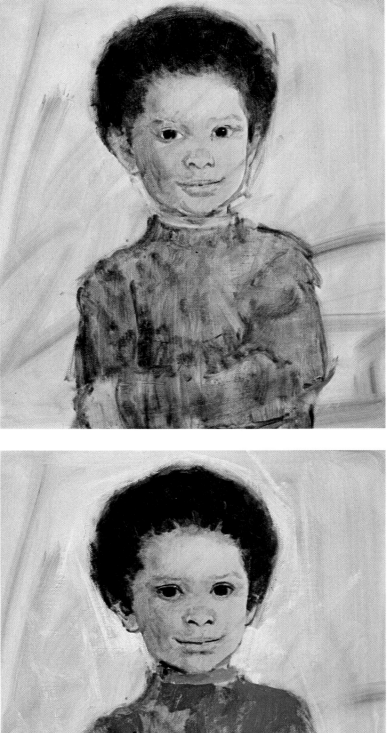

Step 2. A big bristle brush covers the hair with ivory black and ultramarine blue and then darkens the eyes with this same mixture. A round brush picks up this dark tone to draw the lines of the eyelids, the nostrils, and the line between the lips. The bright color of the sweater is a single stroke of alizarin crimson and cadmium red softened with a touch of raw umber. Cobalt blue, raw umber, and white are brushed loosely over the sweater. A pale tone of raw umber and white is brushed over the background.

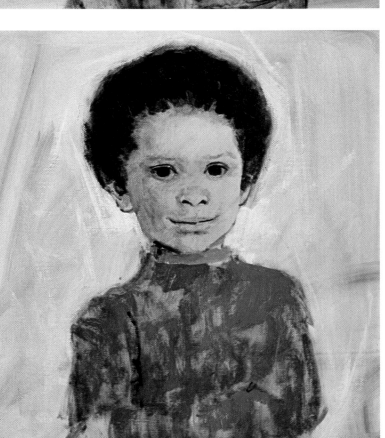

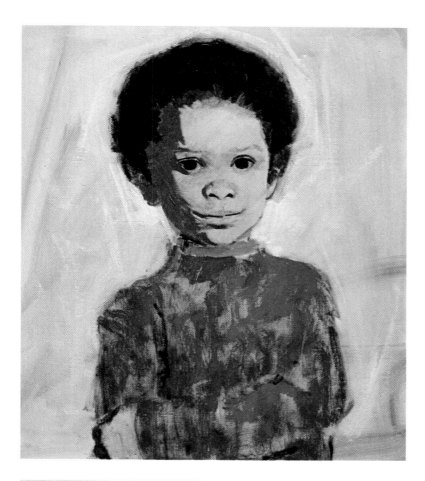

Step 3. The dark tone on the shadow side of the face is blocked in by a big bristle brush that carries a mixture of burnt umber, raw sienna, and cadmium orange. Notice how this mixture is carried over the ear, into the eye socket, and into the pool of shadow under the lower lip. A single dark stroke of this mixture is placed in the corner of the eye and on the shadow side of the nose.

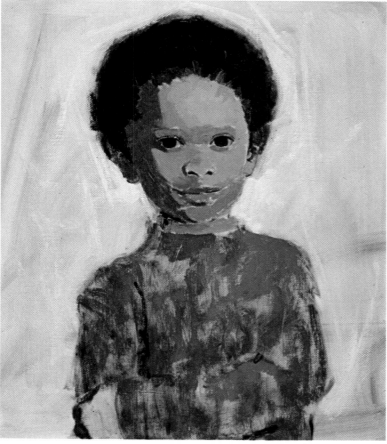

Step 4. The pale tone of the forehead is covered with broad strokes of burnt umber, raw sienna, cadmium red, and white. The darker, warmer tone that falls between the lighted forehead and the shadow side of the face is a mixture of cadmium orange, burnt umber, and white. This mixture, which is really a halftone that falls midway between the light and shadow, is darkened with more burnt umber and cadmium orange as the brush moves down the face to the lips, jaw, and chin. Notice how a single stroke of this mixture defines the shadowy eyelid beneath the eye on the lighted side of the face. Now the entire face is covered with flat tones which will soon be blended.

Step 5. A flat softhair brush begins to blend the flat tones together to create smooth transitions between the lights, halftones, and shadows. The upper lip is darkened and so is the eye socket on the shadow side of the face. Both eye sockets are filled with a warm, soft tone. The tip of a round brush defines the nose and lips more precisely and sharpens the dark lines of the upper eyelids. Subtle touches of ultramarine blue, ivory black, and white add a cool tone to the hair where it overlaps the forehead. The hand is painted with the same colors that appear on the face.

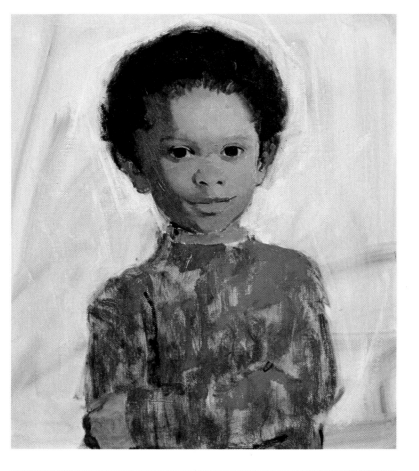

Step 6. A small brush shapes the lips more carefully, darkening the upper lip, the corners of the mouth, and the shadow beneath the lower lip. A flat softhair brush lightens and continues to blend the forehead. The paler hair tone, which was brushed over the edge of the forehead in Step 5, is now blended softly into the skin. Strokes of ultramarine blue, ivory black, and white are carried over the outer edge of the hair to suggest light falling on the dark mass. Thicker strokes of cobalt blue, raw umber, and white now darken the sweater. The background is lightened with additional strokes of white and raw umber concentrated mainly around the head.

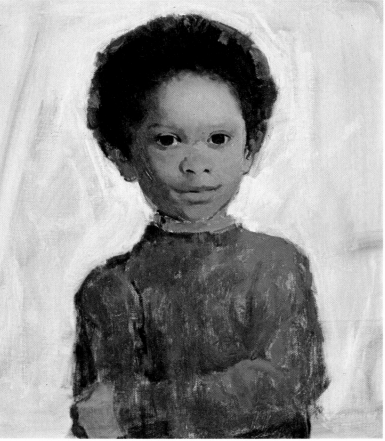

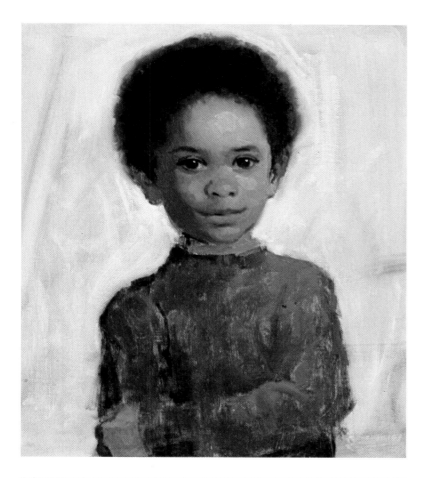

Step 7. The cool pale edge of the hair is blended softly into the surrounding background tone. More white is added to the palest skin tone, and a big bristle brush builds up the lights on the forehead, nose, cheeks, and chin with thick strokes. The whites of the eyes are painted with pure white tinted with raw umber. Highlights are added to the pupils with touches of white also tinted with raw umber. The tip of a round brush draws the dark lines of the eyelids with burnt umber and ivory black. The lower eyelids are warmed and darkened.

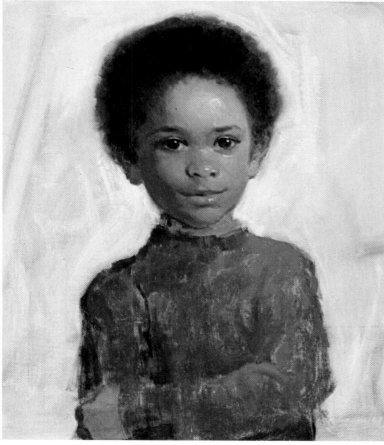

Step 8. The strong touches of light, applied in Step 7, are softly blended into the surrounding skin tones, which grow richer and more luminous. The warm skin tone needs a cool note: the slightest hint of cobalt blue, raw umber, and white is blended into the shadow side of the jaw. Highlights of thick white, softened with a speck of flesh tone, are placed on the forehead, the upper eyelids, the bridge and tip of the nose, just beneath the eye on the lighted side of the face, and on the lower lip.

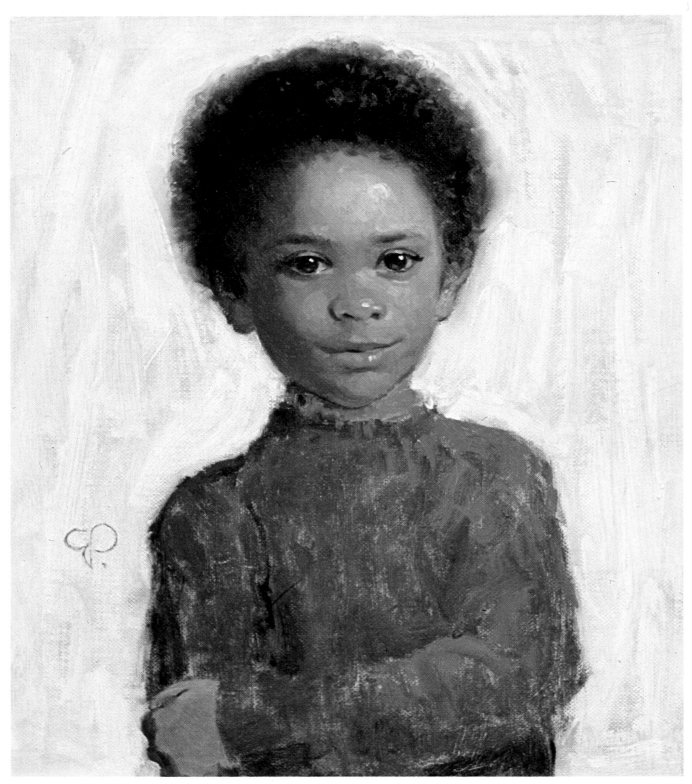

Step 9. The finished painting shows how the lips are warmed with an extra touch of cadmium red. The bright tone of the collar is reflected in the shadow beneath the chin. The whites of the eyes are darkened at the corners to make the eyes look rounder. Small, curving strokes of ultramarine blue, burnt umber, and white pick out individual curls in the hair. Tiny touches of light are added above the eyebrows to dramatize the sitter's eyes. The entire background is lightened with strokes of white and raw umber cooled with a speck of cobalt blue. This cooler background heightens the rich, warm color of the sitter's skin.

Getting to Know the Sitter. When you begin to paint children's portraits, it's best to start with sitters whom you already know—members of your family, friends, neighbors. Since you already know them, your sitters will be fairly relaxed with you. And it's easy to talk to them about how you'd like them to pose, what you'd like them to wear, and how you'd like their hair done. But if the sitter is just a casual acquaintance, or perhaps a stranger, it's a good idea to take some time to get to know the sitter and establish a relaxed, friendly relationship before you begin to paint. When a professional specializes in painting children, he often invites the sitter to the studio a few days before the first painting session—or pays a preliminary visit to the sitter's home, if that's where the portrait will be done. Each professional has his own way of making friends with the sitter. Children are fascinated by the process of painting, and a child may respond with great interest if you show him your paints and brushes, explain how they're used, and perhaps let the child handle them. Other professionals are good at the friendly chitchat that puts a child at ease. To paint children's portraits, you've really got to *like* children—and lots of professionals are perfectly comfortable sitting on the floor, playing with the child and his toys. Some artists make friends with the sitter by using that first session to make some preliminary portrait sketches while the sitter watches, asks questions, and generally enjoys seeing an artist at work. Whether that first session takes place a week before you start to paint or just half an hour before the painting session, it makes the job a lot easier.

Talking to Children. The whole secret in talking to children is to be yourself and to treat the child as a *person*. Small children are *not* amused by "baby talk." Teenagers are *not* impressed when adults pepper their conversations with teenage expressions—which sound natural when a kid uses them, but sound silly and artificial when an adult tries to use them in order to seem like a teenager. Young people of all ages respond to honest, straightforward conversation. Talk simply and openly about yourself, your work, and the portrait. Ask questions and encourage your sitter to ask questions. Don't struggle to make clever conversation or tell lame jokes. The conversation will move along quite naturally if you just talk about how you hope to paint the portrait and how you'd like the sitter to help.

Entertaining the Sitter. When the painting is finally under way, you *will* have to cope with the natural vitality and impatience of children. Whether your sitter is a tiny tot or a teenager, you'll find that children don't like to sit still for very long. That's why professional portrait painters always provide some sort of entertainment to keep the sitter in one place as long as possible. We all know about the hypnotic effect of television—and a television set is probably the most effective device for immobilizing the sitter. For small children, you may want to provide some picture books or toys. Or you can ask the parents to bring along some of the child's own favorite books or toys. Older children may enjoy looking at magazines or at your art book collection. If you have a hi-fi set, you might provide some popular music for a teenage sitter—or suggest that the sitter bring along some favorite records. Be sure to interrupt the pose with frequent rest periods: every fifteen or twenty minutes for a teenager, and more often for a young child. During these rest periods, invite the sitter to look at the canvas and see how the painting is coming along.

Clothing. Always encourage the sitter—or the sitter's parents—to select clothing that's simple, natural, and comfortable. Children don't really like to dress up for a portrait, but prefer loose, casual clothing. Such clothing is not only easier to paint, but the sitter becomes easier to paint because he or she is more relaxed. If possible, discuss the sitter's clothing at least a day before the first portrait sitting so that you can make it clear that the portrait will look best if the sitter's clothes are a solid, subdued color in a simple, unobtrusive style. Explain that a strong color, a blatant pattern, or a dramatic style will distract attention from the sitter's face. If some proud parent insists that the child wear a favorite dress or blouse, ask if you can see it so you can have a chance to say: "Do you have some other favorite that doesn't have such strong stripes?"

Hair. Hair, like clothing, is most "paintable" when it's loose and natural. If a mother insists on sending her child to the hairdresser in preparation for the portrait, ask her to allow a day or two for the hair to loosen up before the painting session. If the hair still looks too tight and artificial when the sitter arrives, you can do a bit of work with a brush or comb. If a boy comes directly from the barber to the studio and his hair looks too neat, hand him a comb and tell him that his hair will look more masculine if he roughens it up a bit.

Preliminary Studies. An adult may be willing to spend as much as two or three hours posing for a portrait, while a teenager will probably begin to fidget after an hour, and a preschooler may start to run around the studio after half an hour. This means that you've got to work quickly when you paint children's portraits. The painting will go more rapidly if you make a number of preliminary sketches in pencil, chalk, or charcoal, before you attack the canvas.

Two Years Old. At this early age a child usually has a very large forehead, round cheeks, and big, bright eyes. On the other hand, the nose, mouth, and chin are small and still undeveloped. The hair is often thin and wispy.

Two Years Old. Seen here from a 3/4 view, the size of the cranial mass—the upper half of the head—is even more obvious. The ear is also quite large in relation to the other features. The nose and lips are tiny and soft. The jaw is round and undeveloped. The neck is slender.

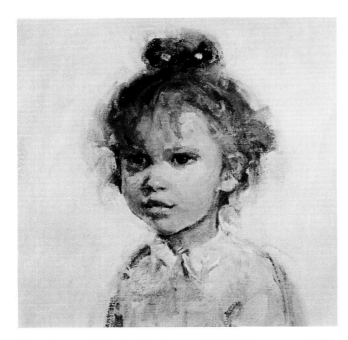

Five Years Old. By the time a child is five years old the forehead and the cranial mass are still large, but they look slightly smaller because the lower half of the face has begun to develop. The contours of the nose and mouth are more pronounced and the jaw has a more distinct shape. The ear is still fairly large in relation to the rest of the features. The neck is still slender and delicate.

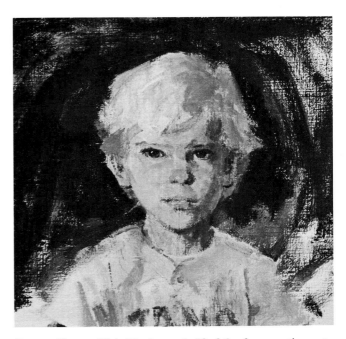

Seven Years Old. The lower half of the face continues to develop. The eyes and ears aren't quite so big in relation to the rest of the face. The bony structure of the nose becomes slightly more apparent. The mouth begins to look more adult. The round cheeks are growing more slender. The bony structure of the jaw becomes firmer and so does the chin.

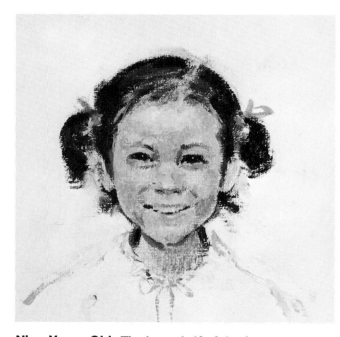

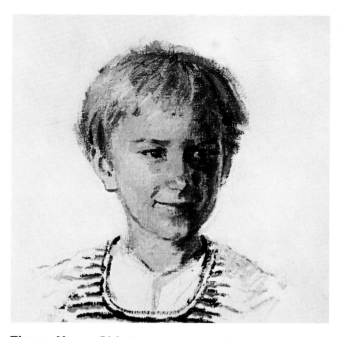

Nine Years Old. The lower half of the face grows more prominent and the features are more sharply defined. The jaw is leaner and the chin is longer and sharper. The mouth grows larger in relation to the other features, while the eyes are a bit less prominent than they were at an earlier age. The ears also look smaller in relation to the other features.

Eleven Years Old. The proportions of the head are very much like those of an adult, although the head is obviously smaller. The head is more elongated and so are the nose and chin. You begin to see the bridge of the nose. The mouth grows more slender, while the lines of the jaw and chin are stronger. The head sits more solidly on the firm cylinder of the neck.

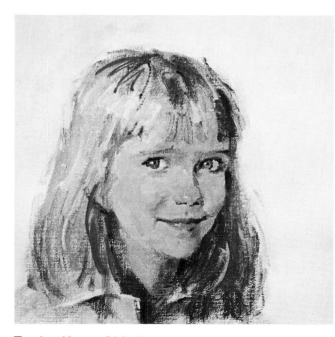

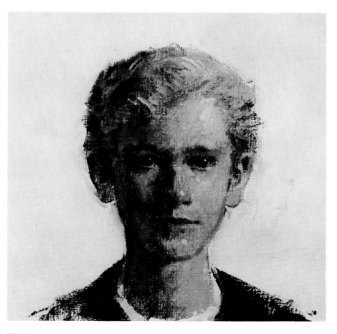

Twelve Years Old. The facial proportions are like those of a mature woman. The line of the brow is sharper. The curves of the cheek, jaw, and chin are more precise. The lines of the mouth are crisp. The eyes are still large and luminous, but they seem smaller in relation to the total head—compared with the five-year-old on the facing page.

Thirteen Years Old. At the beginning of adolescence the face grows longer and leaner. The bony structure becomes more obvious. The nose has a clearly defined bridge. The jaw and chin are firm and solid. The eye sockets grow deeper. The details of the eyelids and mouth are more clearly defined. Yet the face still has a smooth, tender quality because the contours flow softly together.

3/4 Lighting. If you ask portrait painters to choose their favorite type of lighting, most will agree on 3/4 lighting. The light hits one side of the sitter's face, as well as part of the front, throwing the other side of the face into shadow. As you sit at your easel facing this particular sitter, the light is coming diagonally over your right shoulder. The lighted side of the face is at your right, while the shadow side is at your left. One side of the nose is also in shadow. The eye socket on the shadow side of the face is distinctly darker than the socket on the lighted side of the face. The chin casts a shadow on one side of the neck. This is often called *form lighting* because it makes the face look round and three-dimensional.

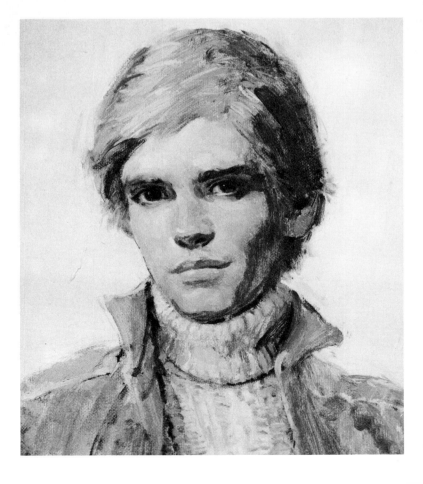

3/4 Lighting. Here's another kind of 3/4 lighting. Now as you sit at the easel facing this sitter, the light moves diagonally over your left shoulder, but the light source is higher—somewhere above your head. The model's face is turned slightly, giving you a three-quarter view instead of the frontal view in the portrait of the girl above. Both eye sockets are in deep shadow, and there's a strong shadow under the nose. One side of the face is in deep shadow, and there's a strong shadow under the chin—but there's only a halftone on the shadow side of the nose. Notice the strong contrast between the light and shadow planes of the hair.

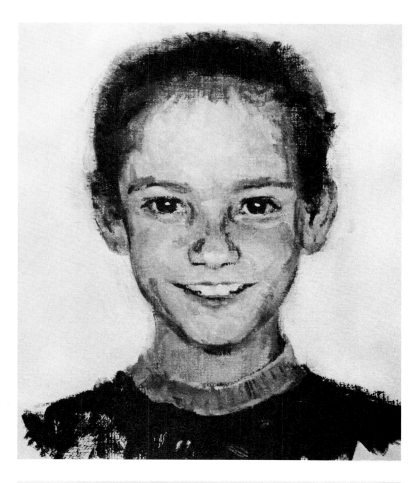

Frontal Lighting. This sitter faces you directly, and the light hits him head-on, as if your own face were the light source. Actually the light is flooding over both your shoulders, and it's equally distributed over the sitter's entire head. There are no big planes of light and shadow. Most of the head is brightly lit, with just a few touches of shadow around the edges of the features, along the cheeks and jaw, and beneath the chin. There are also very soft halftones that lend roundness to the forms of the lower face. Frontal lighting emphasizes the softness and delicacy of the sitter's features.

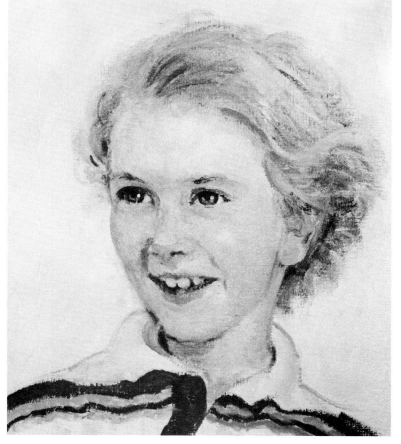

Frontal Lighting. In this example of frontal lighting the sitter has turned slightly. Once again the entire face is evenly lit by light that floods over both your shoulders. The face seems to be one smooth, even tone with slender lines of shadow defining the edges of the features. The curves of the cheeks, jaw, and chin are halftones. This soft, diffused lighting dramatizes the sitter's dark eyes and animated mouth.

Side Lighting. The light comes directly from one side, as if the model is sitting next to a window. The side of the face that's nearest the light source is brightly lit, while the opposite side of the face is in shadow. When you choose this kind of lighting, there's always the danger that the shadow side of the face may be *too* dark. The shadow side of this sitter's face, however, is luminous because she's sitting next to a secondary light source. This secondary source can be nothing more complicated than a white wall or a sheet of white cardboard that reflects the light of the window and bounces some light into the dark side of the face. If you're working with artificial light, place a big light fixture on one side of the head and a much smaller fixture on the other side to provide what photographers call "fill-in" light.

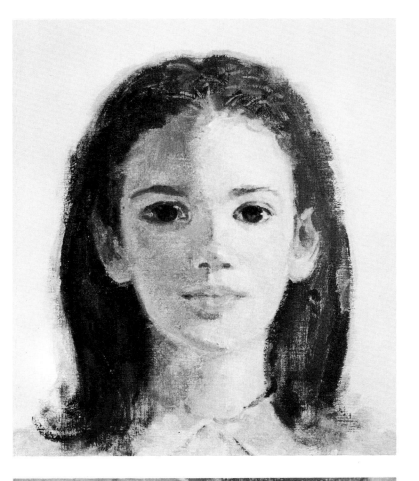

Side Lighting. As the sitter's face turns, the proportion of light to shadow will change. In this case you see more of the shadow side of his face and less of the lighted side. The neck is almost completely in shadow. Once again there's a secondary light source that adds a hint of brightness to the shadow side of the face. Of course, instead of asking the sitter to turn his head, *you* can walk around him to change the proportion of light and shadow.

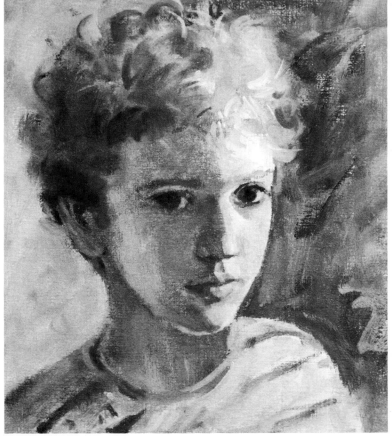

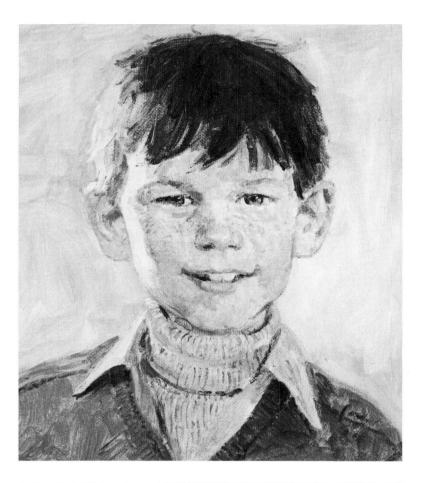

Rim Lighting. When the light source is behind the sitter and slightly to one side, most of the face is in shadow, and there's just a *rim* of light along one side of the brow, cheek, and jaw. This rim of light also appears on his hair and along the edge of one ear. To keep the front of the face from becoming too dark, place a reflecting surface or small lamp where it will lighten the shadows. Now you can see the dark contours of the features more clearly.

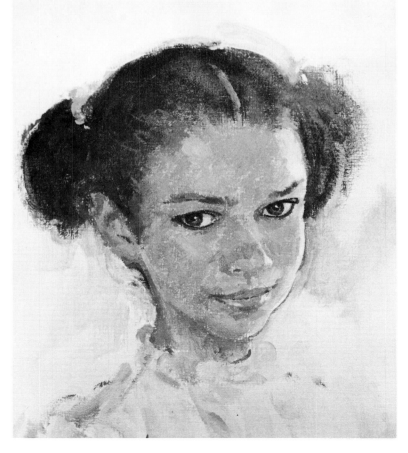

Rim Lighting. As the sitter turns her head toward the light source, a rim of light appears not only on her forehead, cheek, jaw, and chin, but also along the edge of her nose and mouth. The dark side of the face consists mainly of halftones—very much like the effect in frontal lighting. A touch of background shadow is placed next to her cheek to accentuate the lighted edge.

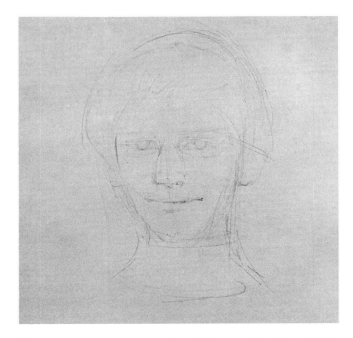

Step 1. The sharpened point of the pencil glides lightly over the paper to define the oval contours of the head, the rounded shape of the hair mass, and the column of the neck, which curves outward toward the shoulders. The pencil draws a vertical center line down the face and horizontal guidelines to locate the features. Then a few lines suggest the eyes, nose, mouth, and ears.

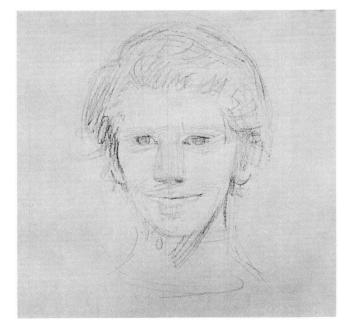

Step 2. The pencil presses slightly harder to produce the darker lines that sharpen the contours of the face, hair, and features. Working with parallel lines, the pencil begins to suggest the shadows within the eye sockets and the larger ear, along the side of the hair and beneath the nose, lower lip, and chin.

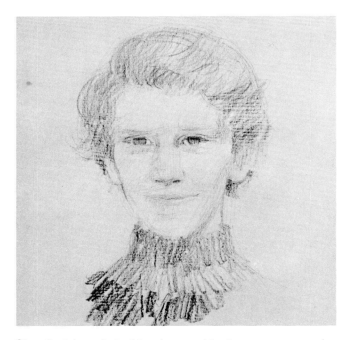

Step 3. A kneaded rubber (putty rubber) eraser removes the excess guidelines. Moving lightly over the face the pencil begins to sharpen the features; indicates shadows along the brow, cheek, and jaw; darkens the hair; and suggests the weave of the sweater with quick, scribbly lines.

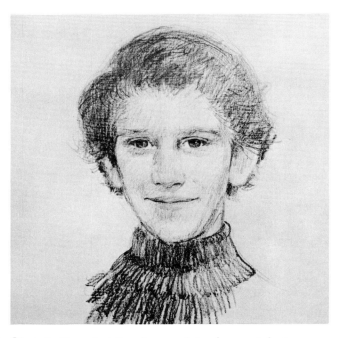

Step 4. Now that the shapes of the face and features are clearly drawn, the pencil presses harder to make darker strokes that define the shapes more strongly. The eyes, nostrils, and mouth are redrawn with darker lines. Moving lightly back and forth, the pencil begins to add halftones to the face and then darkens the hair. The sweater is darkened too.

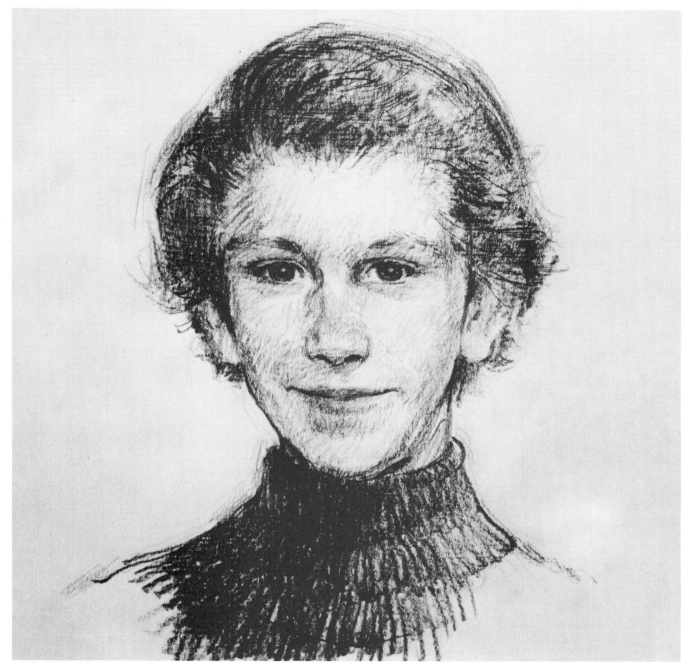

Step 5. The pencil continues to move back and forth, drawing quick parallel lines to complete the shadows and half-tones on the face. The pencil presses down hard to darken the eyes, nostrils, and lips. The eraser cleans away excess lines to lighten the forehead, the cheeks, the chin, and the bridge of the nose. The point of the pencil is used to sharpen the lines of the jaw and chin. Then the *side* of the lead completes the darks of the hair and the sweater with broader, rougher strokes. It's possible to soften and blend the strokes of the pencil with a fingertip, treating the marks of the pencil like wet oil paint. But it's good discipline to leave the pencil strokes intact, starting with lighter strokes and then making the strokes darker and more precise in the final stages of the drawing.

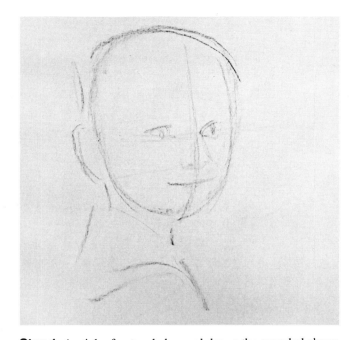

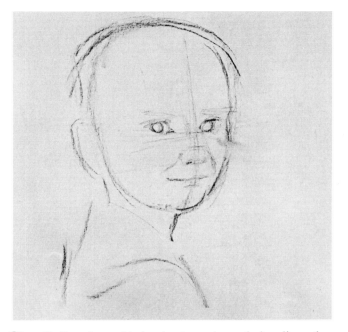

Step 1. A stick of natural charcoal draws the rounded shape of the head with curving lines. A vertical center line aids the placement of the features, which are quickly indicated with a few strokes. The shapes of the ear, neck, and shoulder are suggested with the minimum number of lines. The roughly textured paper is specially made for charcoal drawing.

Step 2. Pressing a bit harder to make a darker line, the charcoal stick retraces the contours of the face and draws them more precisely. The features are also defined more clearly. It's easy to wipe away the original lines with a fingertip, a dry cloth, or a cleansing tissue.

Step 3. The tip of the stick is brushed lightly over the shadow sides of the forehead, cheek, jaw, neck, and nose in a series of parallel lines. A fingertip blends some of these lines together to form a soft, continuous tone. Then the charcoal is held at an angle and the side of the stick makes broad strokes around the head to suggest the background. Finally, the eyes are darkened.

Step 4. The background is darkened more to silhouette the lighter shape of the head. The shadows on the face are further developed with light, parallel strokes that are gently blended by a fingertip. The tip of the charcoal stick darkens the contours of the eyes and the details of the nose and the mouth. Heavier strokes suggest the texture of the hair.

Step 5. Gliding lightly over the face the charcoal stick darkens the shadows very selectively—on the cheek, jaw, chin, neck, and side of the nose. These strokes are left unblended. The sharp tip of the charcoal stick draws the dark lines of the eyes with precise strokes, darkens the nostrils, and strengthens the line between the lips. The side of the stick is used to darken the background with rough, heavy strokes that are left unblended. The tip of the stick picks out a few more strands of hair, and the portrait is complete.

Notice how the entire face is rendered with soft, pale strokes that merge into delicate tones. Only the features are drawn with sharp lines. The texture of the paper roughens the strokes as canvas roughens the mark of the brush. This drawing is made with natural charcoal, which is very dry, soft, and easy to smudge; thus it handles like paint. You can also buy charcoal pencils, which make a firmer line and don't smudge as easily—if you prefer a portrait that looks more like a pencil drawing.

Step 1. The tip of a round softhair brush draws the oval contours of the face, the ragged shapes of the hair, and the first indication of the features with a fluid mixture of tube color and turpentine. Much of the work in this oil sketch will be done with this liquid mixture, which is only a bit thicker than watercolor. The painting surface is canvas-textured paper.

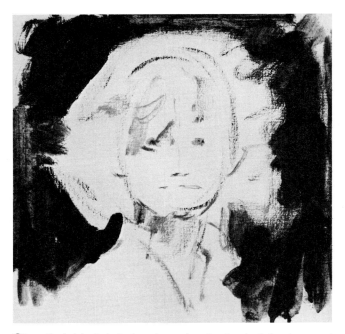

Step 2. A big bristle brush washes in the dark background with fluid strokes of tube color and turpentine. This fluid mixture is darker because it contains somewhat less turpentine. Now the pale tone of the hair is clearly silhouetted against the surrounding darkness.

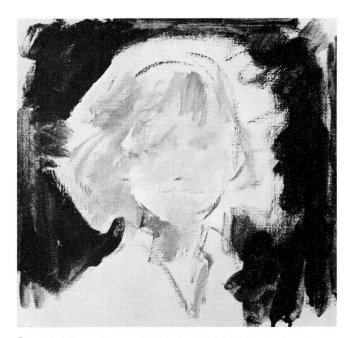

Step 3. The artist *usually* begins by blocking in the shapes of the shadows. But this is a rough, impulsive sketch; he decides on a different approach. The face is quickly covered with a pale tone that represents the lights. A few darker dabs suggest the eye sockets. Then the brush moves swiftly around the face to suggest the shadow tone on the hair and neck.

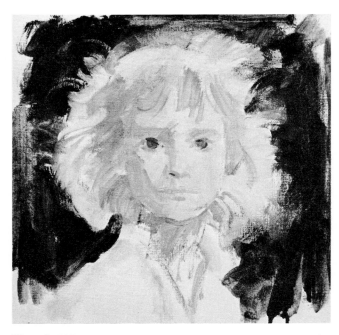

Step 4. This same shadow is carried swiftly over the darker sides of the head and features, which are now almost complete. Smaller strokes of this tone indicate the dark upper lip, the shadow beneath the lower lip, the underside of the nose, and the lower eyelids. The eyes are placed with two quick touches. And the brush scribbles more shadow strokes over the hair.

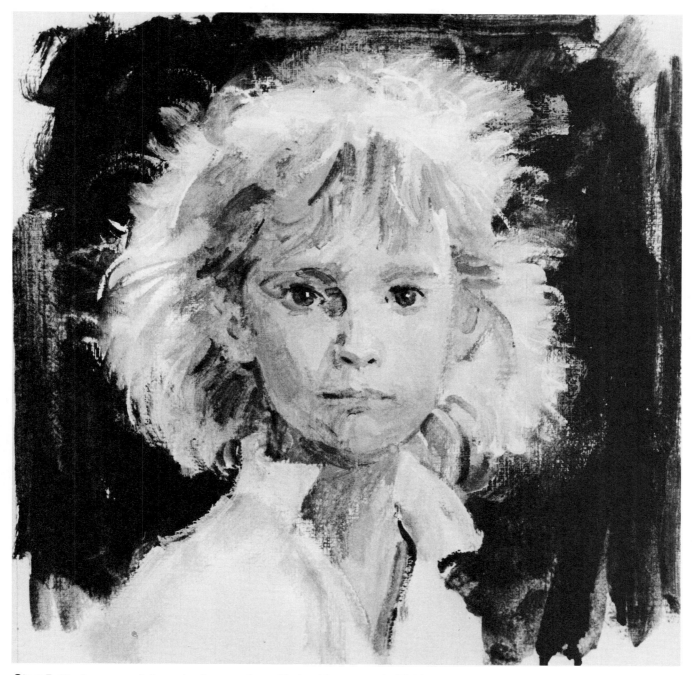

Step 5. Having covered the entire face, neck, and hair with broad strokes of light and shadow in the shortest possible time, the artist finishes the sketch with the last few touches of detail. The tip of a round softhair brush draws the dark lines of the eyes, eyebrows, nostrils, and mouth. A few strokes of shadow darken the corner of the eye socket on the darker side of the face, the corner of the nostril, the underside of the earlobe, the hard line of the jaw, and the line of the chin. The brush scribbles more shadows into the hair that falls over the forehead, over the ear, and behind the neck. Picking up some pale color, the tip of the brush suggests some bright strands of hair that stand out against the darkness. A few rapid strokes indicate the pale color of the blouse and the dark shadow within the collar. The entire sketch is painted with tube color diluted with turpentine to a fluid consistency for rapid brushwork. Such a sketch is often used as a preliminary study for a more finished painting. But the oil sketch has a free, spontaneous quality which is satisfying in itself—and is often just as enjoyable as a more polished painting that takes many more hours of work.

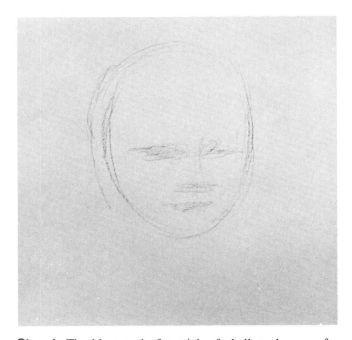

Step 1. The blunt end of a stick of chalk makes a soft, rough stroke. This chalk drawing is made on a sheet of gray paper. The oval shape of the head is drawn first. Then the tip of the chalk is lightly scribbled back and forth to create ragged patches of tone for the features.

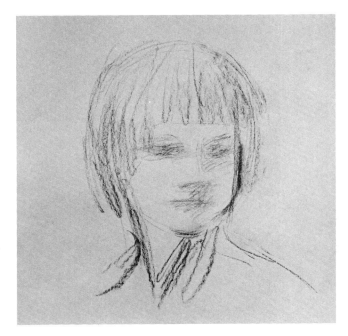

Step 2. Still working with free, scribbly strokes, the chalk surrounds the head with hair and indicates the collar and the shoulders. Moving lightly over the face the chalk adds more tone with delicate, parallel lines. Now the eye sockets, the underside of the nose, and the mouth are darker. There's also a suggestion of tone on the shadow side of the face.

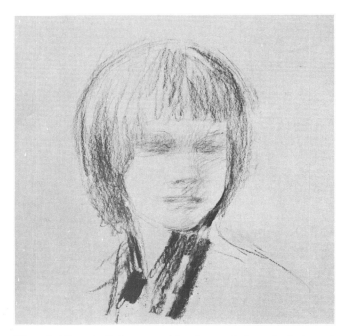

Step 3. The chalk is pressed harder to darken the hair and the collar. A sharp corner of the stick pulls a dark line around the contour of the jaw and chin. Delicate lines begin to define the contours of the eyebrows, the eyes, the nostrils, and the lips. More shadow is added to the eye-sockets.

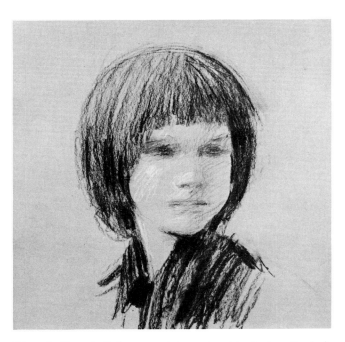

Step 4. The chalk is pressed down hard to darken the hair and the blouse as well pick out some individual strands of hair. The darks of the eyes begin to appear, while the nose and the lines of the mouth are more sharply defined. A stick of white chalk adds some strokes to the lighter side of the face and the nose.

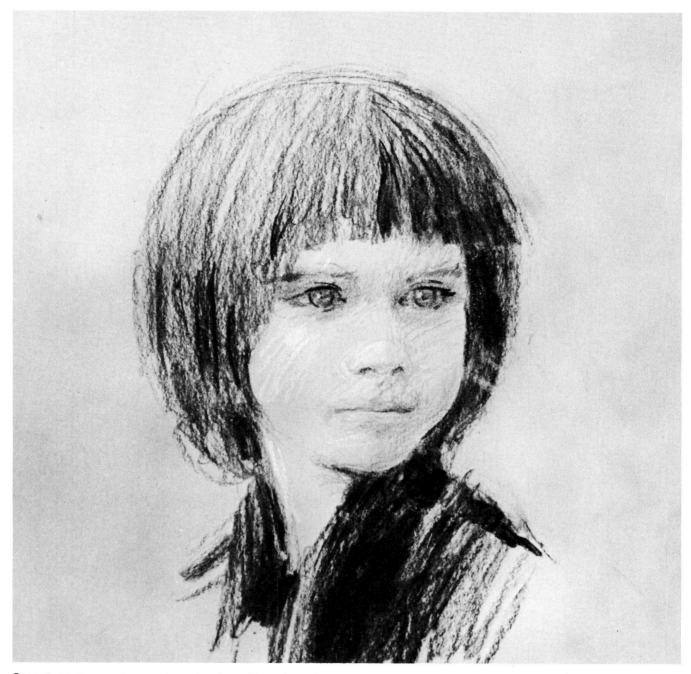

Step 5. Until now the eyes have just been blurred patches of tone. Now a sharp corner of the tip of the chalk draws the precise lines of the eyelids and the iris as well as darkening the softer lines of the eyebrows. The nostrils and the lines between the lips are drawn more precisely. The collar is darkened even more, and this darkness is carried up alongside the cheek to make that round contour more prominent. The sharp corner of the chalk picks out some individual strands of hair at the center of the forehead. More strokes of white chalk are added to the lighted side of the neck, the lighted cheeks, the tip of the nose, the upper lip, and the chin. The drawing is still rather pale. The artist is building up his tone and his details very slowly.

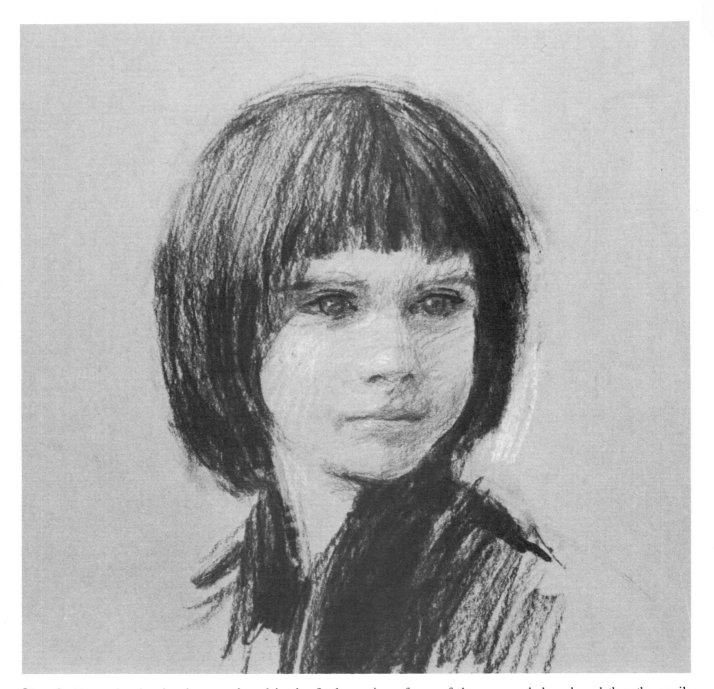

Step 6. The entire drawing is strengthened in the final stages. The chalk is pressed down hard to produce the thick, dark strokes that complete the hair. Notice that the strokes all follow the downward curve of the hair, growing darker toward the bottom where the hair is in shadow. The blouse is darkened too, so now the entire head is framed in darkness. Moving more lightly over the face the chalk works back and forth to deposit small strokes that gradually build up and darken the shadow side of the face, the eye sockets, the tone between the eyes, the underside of the nose, the upper and lower lips, and the chin. The upper lip—which is usually in shadow—is darkened and so is the shadow beneath the lower lip. The corner of the mouth is darkened. The lines of the eyelids are darkened with firm strokes. The inner forms of the eye are darkened, and then the pupils (which first appeared in Step 5) are strengthened. The white chalk adds a few more strokes to the lighted side of the face and to the neck. Then the sharp corner of the white chalk adds a single highlight to each eye, a touch of light to the corner of the eye socket on the lighted side of the face, the highlight alongside the tip of the nose, and a touch of light to the lower lip. Looking at the finished drawing, you can see that most of the work is done with the black chalk. The white chalk is used very selectively—to heighten the lighted side of the face and to add highlights. After you've tried black and white chalks on gray paper, you may enjoy trying dark brown and white chalks on tan paper.